WILDLIFE

THE NATURE PAINTINGS OF
CARL BRENDERS

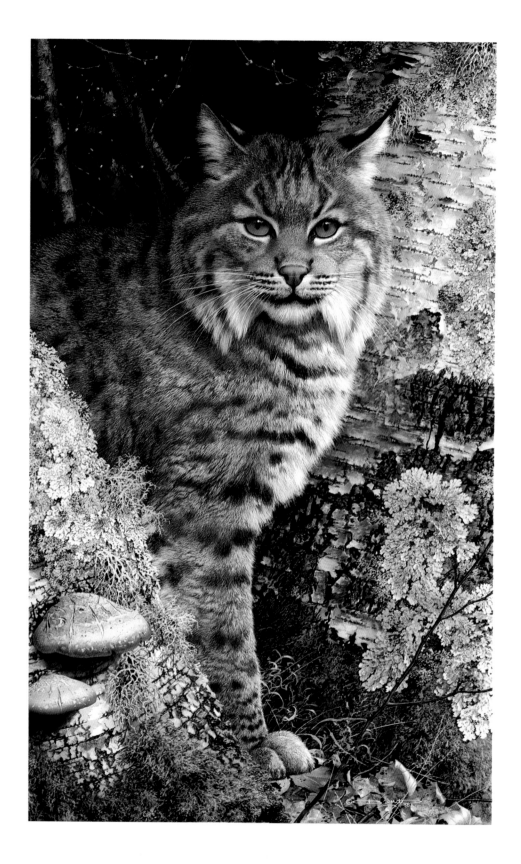

WILDLIFE

THE NATURE PAINTINGS OF
CARL BRENDERS

HARRY N. ABRAMS, INC., PUBLISHERS
IN ASSOCIATION WITH
MILL POND PRESS, INC.

Dedication

With my work, I hope to contribute to saving all the beauty of wild creatures
and their habitat for future generations. Please join me in my efforts to save
this wonderful planet—our good mother—the Earth.
Carl Brenders

Editor: Robert Morton
Designer: Dirk Luykx

For Mill Pond Press, Inc.:
Laurie Lewin Simms, Nicki Watts,
Linda D'Agostino Clinger, Dana Cooper

Frontispiece: Forest Sentinel—Bobcat
30½ x 18½", gouache on board, 1988

Photograph credits: page 91, Norman Lightfoot; page 92,
Alfons Brenders; page 96 top, collection the artist; page 96 bottom,
Steve Martin

Library of Congress Cataloging-in-Publication Data
Brenders, Carl.
Wildlife : the nature paintings of Carl Brenders / by Carl Brenders.
p. cm.
ISBN 0–8109–3977–0
1. Brenders, Carl–Catalogs. 2. Wildlife art–North America–
Catalogs. I. Title.
ND673.B546A4 1994 94–6382
759.9493–dc20

Published in 1994 by Harry N. Abrams, Incorporated, New York
A Times Mirror Company
in association with Mill Pond Press, Inc., Venice, Florida,
publisher of Carl Brenders' limited edition art prints.
All rights reserved. No part of the contents of this book may be
reproduced without the written permission of the publisher

Printed and bound in Italy

CONTENTS

Foreword by Carl Brenders 6

The Paintings 8

A Brief Biography of the Artist by Dana Cooper 90

FOREWORD

MY REAL LOVE, since childhood, has been nature and the wild places. The beauty, peace, and truth found there have no equal. These remote places and the many beautiful species that live there have always been my inspiration; that is why I continue to paint them.

Why do I paint like a maniac, so realistically?

I sometimes ask myself this question when I think about the paintings of Carl Rungius, Robert Kuhn, Richard Friese, or Wilhelm Kuhnert, wildlife artists whose work has a loose, impressionistic style. But whether it is impressionistic or realistic painting, in the end it is the vision of the individual that matters. For me it is not crazy to paint all those little rocks and fallen pine needles, because the vibration of their textures makes an aesthetic whole of the animal, the plant life, and the landscape in the painting.

What fascinates me is that when I paint all this detail in nature, I paint, in fact,

a complete story that is sometimes hundreds of thousands of years old. For example, it takes some lichens three hundred years to grow as big as a quarter. It is worth it to me to spend a few hours more to paint them as they really are. I don't have to force myself to do that; the discipline is part of my being. For me, it would be a shame and a lack of respect to all this beauty not to paint it realistically.

Nature and its wildlife have always had a big place in my heart, so it is obvious that wildlife art would be my final direction. The aesthetic perfection in the natural world has always obsessed me. I have painted many types of art in many styles, but with my hyperrealistic approach to painting no other subject suits me as well. My nature paintings give me a feeling of satisfaction that I never had with any other way of painting. For me, the challenge is to accomplish something good and to bring it to an end that surprises even me.

If one direction in art nowadays makes sense, then it is surely wildlife art. I suffer when I see the decline of the wild virgin areas. Wildlife art can affect the future of our planet. It may have only a small effect, but it is a contribution in a certain way to the conservation of our natural world—without which I could not live.

Carl Brenders
Antwerp, Belgium, 1994

Close to Mom
23 x 31½″, gouache on board, 1987

BEING a real nature lover, I sometimes have the feeling when I am hiking in the wild that there is a chance I will disturb peaceful scenes such as the one I have painted here. In this painting, I wanted to show the wildness of the bear, but also the tenderness of the mother grizzly and her relationship with her cubs.

A mother grizzly can become aggressive and dangerous when approached by a hiker; they are very protective of their young. The only way I knew to get this close to bears in a natural setting was in my imagination. I feel very fortunate to be able to do this, and I think that this is a big advantage that artists have; we can imagine a scene with such reality that the impossible becomes possible.

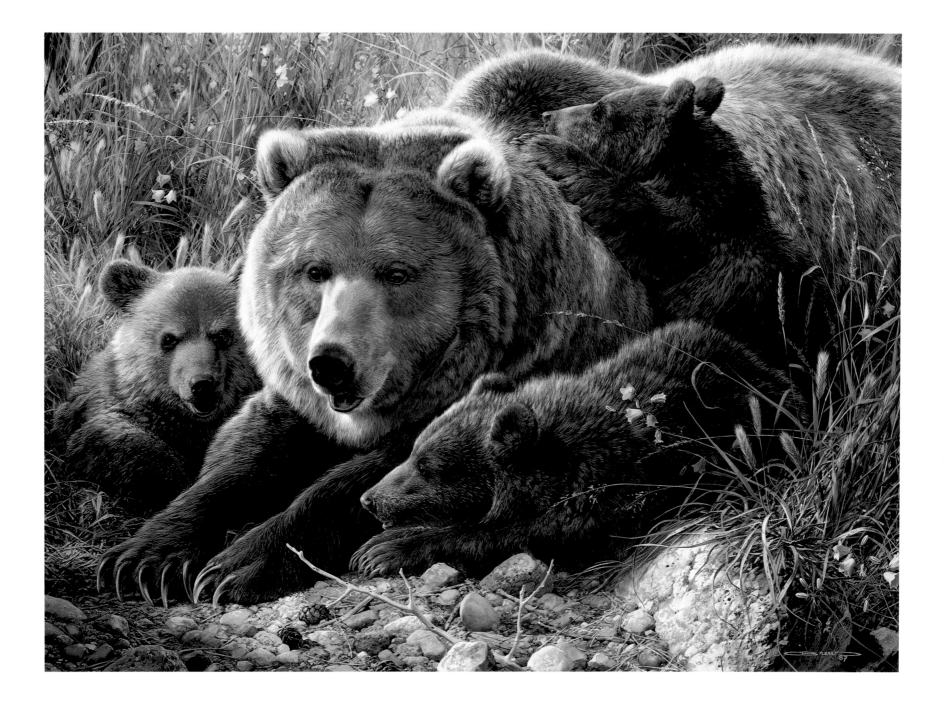

Mother of Pearls
27½ x 38¾", gouache on board, 1993

A FEMALE polar bear can be a dangerous animal, and she becomes really dangerous when she has cubs. But if there is no danger to the young, one cannot imagine a more peaceful mother.

Polar bear cubs are beautiful little creatures. Their fur is incredibly soft, and with the northern sunlight on it lots of nice reflections appear on the fine hairs—like the reflections on pearls. I was surprised that these white animals can be so colorful in the snow. Most polar bears are not white at all. I got so excited about their creamy color, combined with the sky's blue reflections on the snow, that I could not wait any longer to make this painting, although so many other subjects were waiting.

In the painting I wanted to have the feeling of being part of that family, close to that big, soft, wild mother.

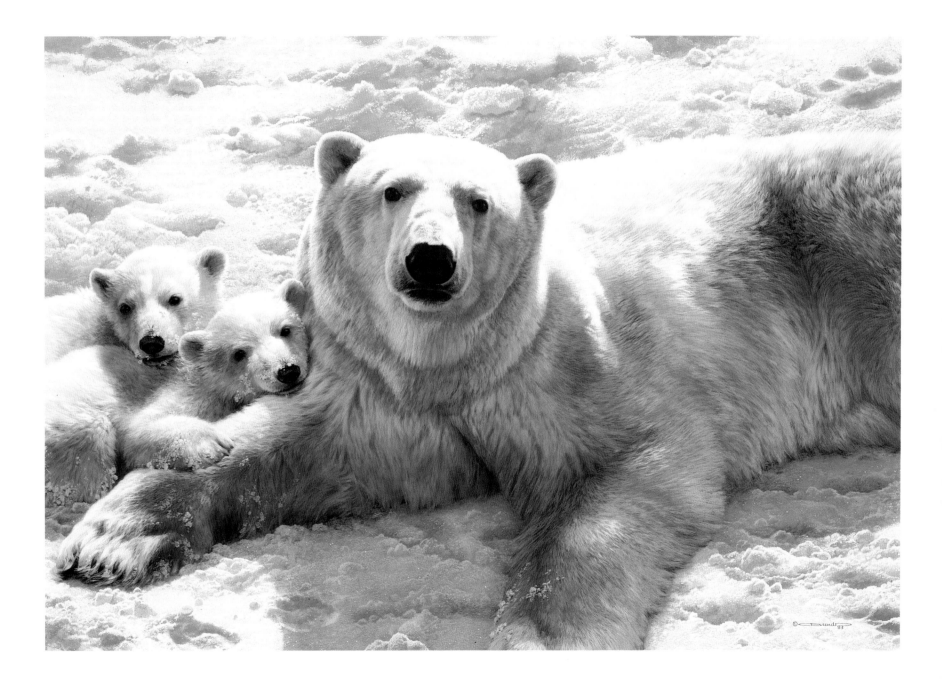

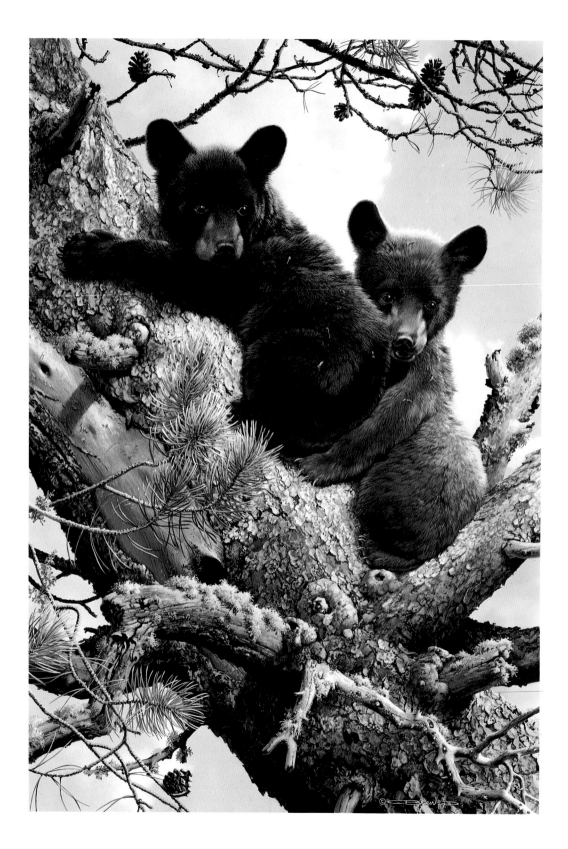

High Adventure—Black Bear Cubs

28¾ x 19½", mixed media on board, 1987

WATCHING children at play, I always enjoy their spontaneous movements and tremendous flexibility, even when their behavior sometimes becomes uncontrolled. The tendency to play all the time is one of the great charms of childhood.

Watching young animals, one can find the same behavior. The playful expression in their eyes seems much like that of human youngsters. Children's apparently unlimited energy for playing is amazing, as is their unceasing inspiration to find new games.

Young black bears exemplify play in every way, and I decided to create a painting based on them. When I learned in my reference books that both cinnamon and black cubs can occur in the same litter, all the elements were there to do this painting. Observation in the wild was not completely at the source of this painting; it was also imagination, coupled with a particular empathy for this most American of all bears, whose scientific name is *Ursus americanus*.

Roaming the Plains—
Pronghorns

33⅜ x 23¾", mixed media on board, 1988

SEEING pronghorn antelopes from the window of a car is enjoyable, but observing them in the field is thrilling. Crossing the great plains in the western United States, one can see many of them. I saw lots of pronghorns in Colorado, but my best sightings were in Yellowstone National Park.

Even in Yellowstone, where animals generally seem very tame, I found these elegant prairie-roamers to be highly alert. They did not allow me to come close to them as the elk did. Every time I tried to approach the pronghorns they ran a little farther. I was, however, able to get many different impressions of them against backgrounds of different scenery as they ran off. I felt a little like a predator as I spied on them.

Being together with pronghorns in their own habitat gives me a special feeling. I was especially excited by the harmony of the animals' beige-brown hair, the bluish green of the sagebrush, and the hot yellow of the rabbit brush. This combination of colors is one of my favorites, and it was one of the reasons this painting was so enjoyable to make.

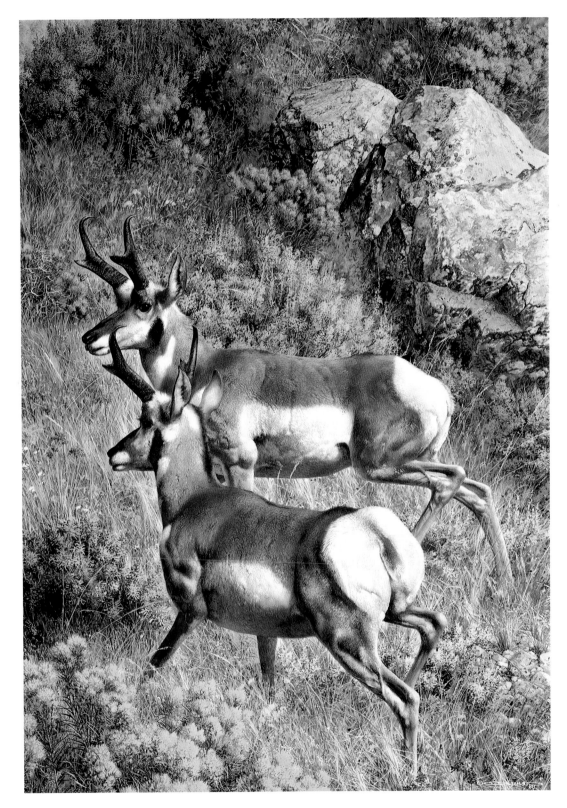

Power and Grace

27¼ x 39″, mixed media on board, 1993

IT'S OFTEN frustrating to see animals on nature hikes, because they almost always run away; one rarely sees them up close. I bring the animals close to the viewer to bring some renewal to wildlife art. What I paint is nearly impossible to see in the wild. In my scenes of nature, I like to share the experience of being within the intimate world of the animals—a little moment in paradise.

When I paint deer, I almost feel part of the herd. I can imagine running with the herd, following the white flag in front of me, jumping over obstacles. I feel the textures of the bodies of the animals in my mind—the soft, shiny nose, the smooth fur, the beautiful white tail. Of all the deer family, whitetails are by far the most beautiful. The way they run and jump is a delight. For me, their eyes reflect all the beauty of wild nature.

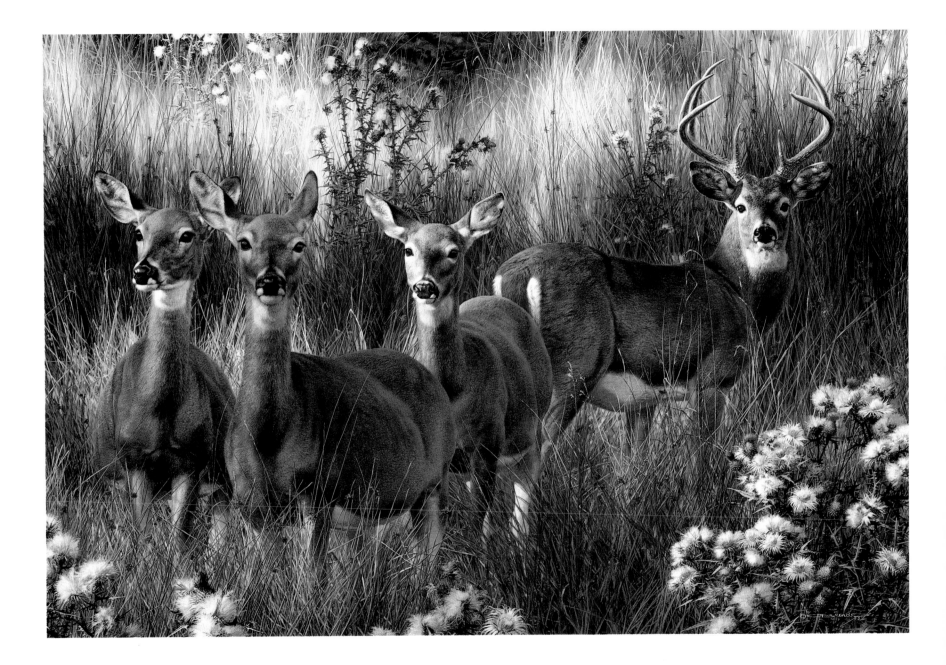

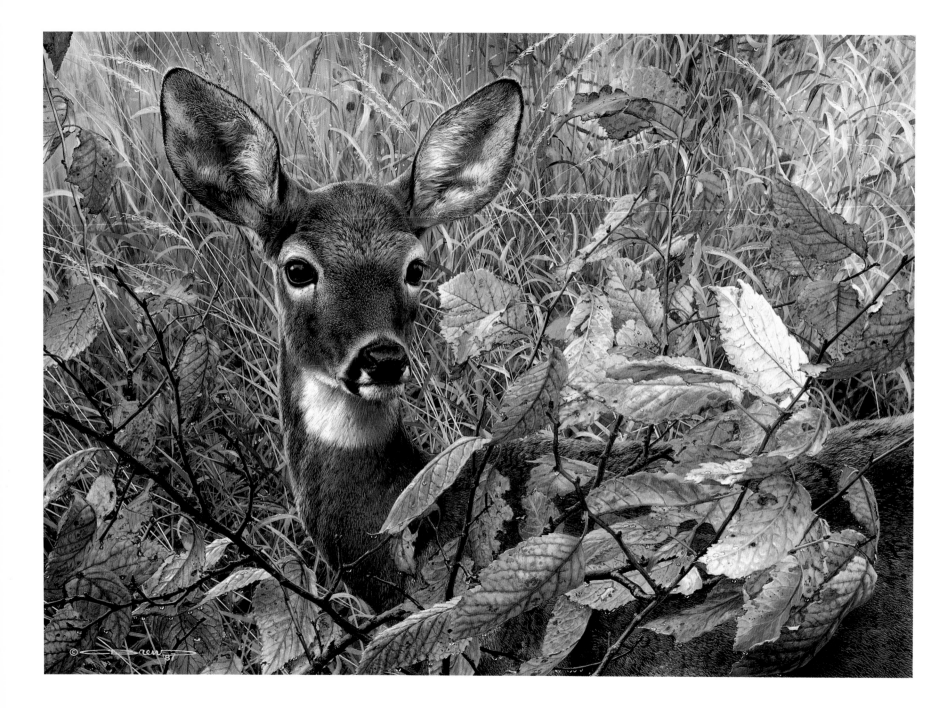

Autumn Lady
21½ x 29″, gouache on board, 1987

IT IS quite unusual to see a painting of a female deer. Most wildlife artists prefer to paint males, because of their dramatic antlers. My challenge in this painting was to paint a doe in an interesting yet natural way. The idea for it had been ripening in my mind for a long time. I have always been enchanted by the beautiful eyes of the female deer; I just needed a good background.

During a trip to Canada to study the autumn colors, I saw a whitetail doe nearby watching me with curiosity. It was raining and cold, but the light was very soft and the moment so beautiful that I completely forgot about the weather. This encounter—the inspiration for the painting—left a happy feeling in my heart for the rest of the day.

A Hunter's Dream
27½ x 38″, mixed media on board, 1988

THE FIRST bugling elk I ever saw was in Yellowstone National Park. The scenery, not far from Old Faithful, was exactly as it is in my painting. The elk was herding stray cows back into the clearing. I cannot describe how excited I was to witness this scene—it was an impressive moment just begging to be painted.

The rutting season of the American elk begins in mid-August and peaks some time between mid-September and mid-October. For the bulls, the mating season is a time of constant vigilance—fighting for dominance, chasing females, and breeding. During this time, their loud, fierce bugle calls announce their presence to competing males and available females. At night, an elk's bugle can be one of the most terrifying sounds on earth.

At the end of the rutting season, the bulls lose interest in the cows and gather once again in bachelor groups. During the preceding period they may have suffered a weight loss of more than a hundred pounds. Depleted of energy, they feed continuously to replace the lost stores of fat that they will need in order to survive the coming long winter.

The title of this painting, *A Hunter's Dream*, must not be misunderstood: the elk will always remain a hunter's dream because it will be forever alive in my painting and never be shot.

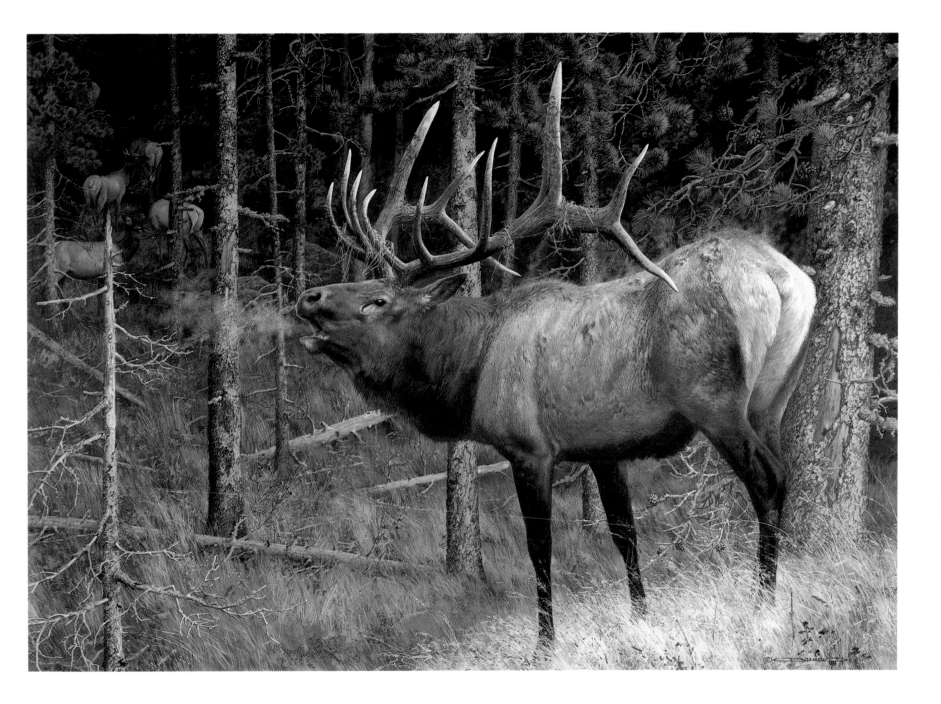

Full House—Fox Family
24⅞ x 35″, gouache on board, 1989

I HAD been wanting to do an important fox painting for a long time and I thought a close-up of four young foxes would make a very decorative painting—you could say a painting full of foxes. I was inspired by a photograph I had seen of four young fennecs—African desert foxes with very large ears.

In my preliminary sketch, one of the four young kits turned out to look a bit too adult, so I decided to make a mother out of it. I did another sketch, but I was not happy with three kits. Because foxes can easily have six in a litter, I added two more young ones, which was considerably more work. It was worth it.

While I was finishing the painting I thought that the face of the mother was perhaps a little too ordinary. To give her a special look that would be different from most fox paintings and to make it more realistic, I painted her licking her nose.

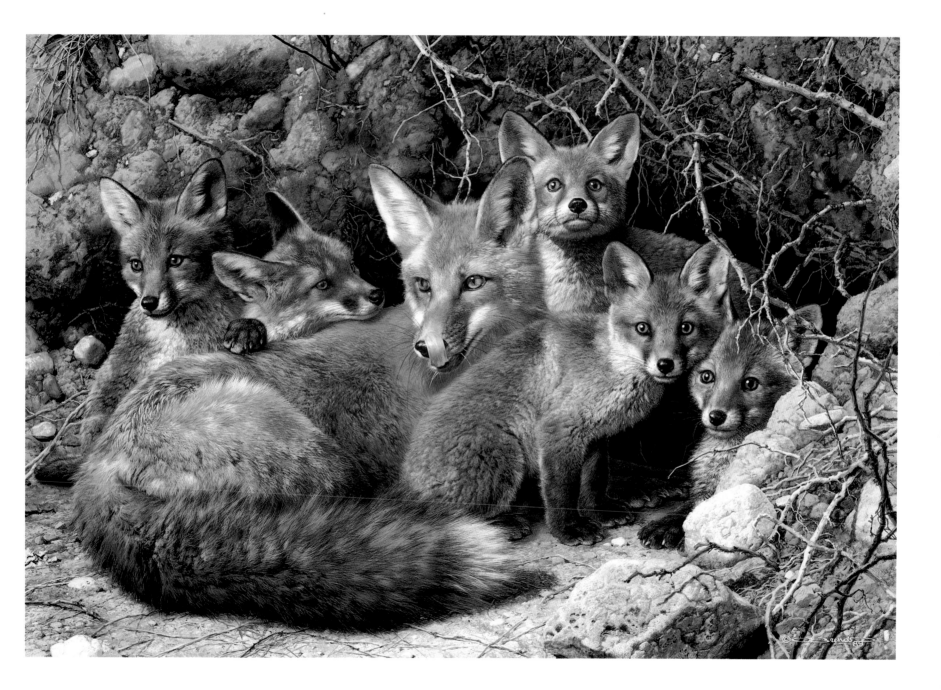

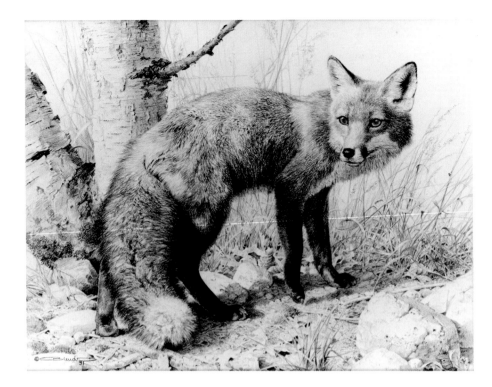

Red Fox Study
12¼ x 15¾″, pencil on board, 1991

AN IDEA for a painting can grow in my mind a long time before it is born. While working on other paintings, I will sometimes make sketches, since I often have many ideas waiting to be painted. It's good for me to put these ideas down in the form of a sketch; sometimes I can't resist going further and the sketch becomes a full-fledged, finished pencil drawing.

This drawing was the first idea for what eventually became my painting *Pathfinder—Red Fox*. I thought the sketch was too quiet and that the painting needed more action, so I portrayed the fox running, as if it was following a track. That not only led me to the title, but it also gave me the opportunity to paint in more of the background scenery, which for me is as important as painting the animal itself.

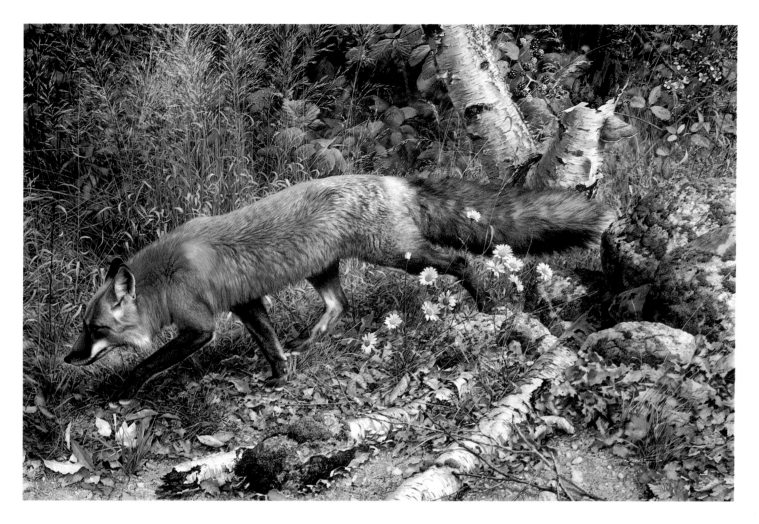

Pathfinder—Red Fox
25½ x 38″, mixed media on board, 1991

AMONG the canids (the dog family), foxes are my favorites, even more so than wolves. This is probably because of their coloration—subtle shades of red and gray, black legs, and a beautiful tail. The fascinating thing about foxes is that they adapt to every situation; one could call them opportunists. They even manage to survive in the city of London.

The attitude of a fox in pursuit of prey gives him a unique, streamlined appearance. Foxes, just like dogs, have a tremendous sense of smell, and that's mostly the way they find their prey—by smelling the tracks. I can remember a lot of encounters with foxes when I was a young boy scout, and that helped me to choose the title *Pathfinder*.

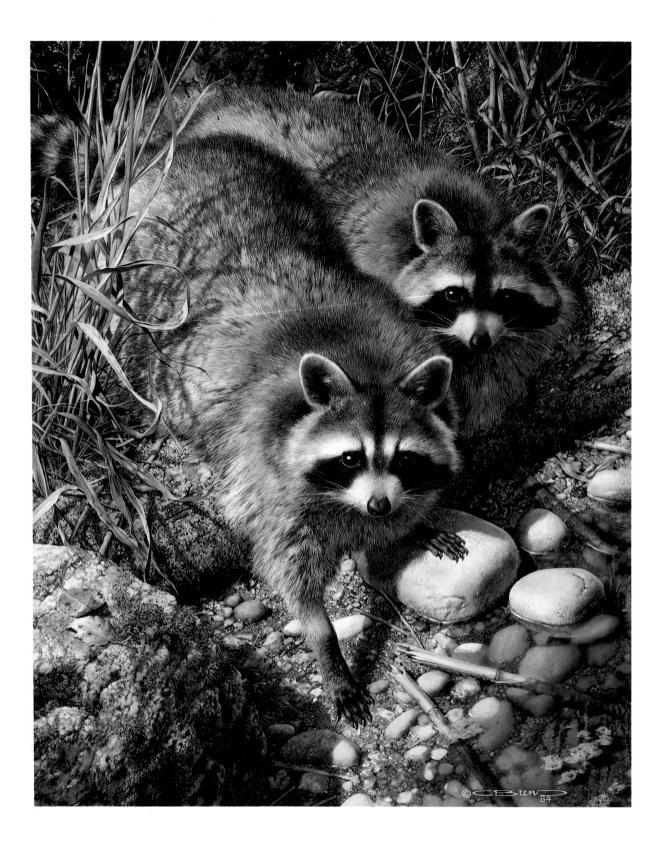

Waterside Encounter

27 x 21½", mixed media on paper, 1984

AS A European wildlife artist, I find it challenging to paint North American subjects. A few North American mammals now also live in Europe: the chipmunk, gray squirrel, muskrat, and raccoon. Although the raccoon population is increasing at an alarming rate in the Bavarian forests, I have found it difficult to observe them. While doing fieldwork in the Florida Everglades, however, I had the opportunity to watch them closely. It was there that I had the inspiration to do this painting.

Although normally the raccoon is a solitary, nocturnal animal, I often saw several together, even in bright afternoon sun. I guess they were the young ones. They were either very curious or hungry, because they approached me and even touched my hands. Such contact with a wild animal is always a great sensation for me.

The unforgettable look of those curious eyes remains in one's spirit, and for me, the feeling expressed itself in the form of this painting. I especially enjoyed depicting the fine nuances of their fur, which was different for each individual raccoon. The color ranged from gray to fine brownish and ocher. I pictured them near water because raccoons have the habit of seeming to wash their food before they eat it. That is why we call them "wash bears" in Europe. It was enjoyable to capture the transparent effect of the water, and the contrasting look of the wet and dry stones.

Double Trouble—Raccoons
15⅝ x 19", mixed media on board, 1986

HAVING long been fascinated by raccoons, it is not difficult for me to find an excuse to make another raccoon painting. Their black-and-white masks go well in many natural settings.

The inspiration for this painting came to me in a zoo which has a very good imitation of the biome where these animals live. The animals were as I like them; they were active and curious and were trying to catch a butterfly. Such scenes are difficult to observe in the wild. Biologists who spend a lot of time in nature might have the opportunity to catch such moments: I was happy to find it in a zoo and I was anxious to finish my painting of these two beautiful animals while my inspiration was fresh.

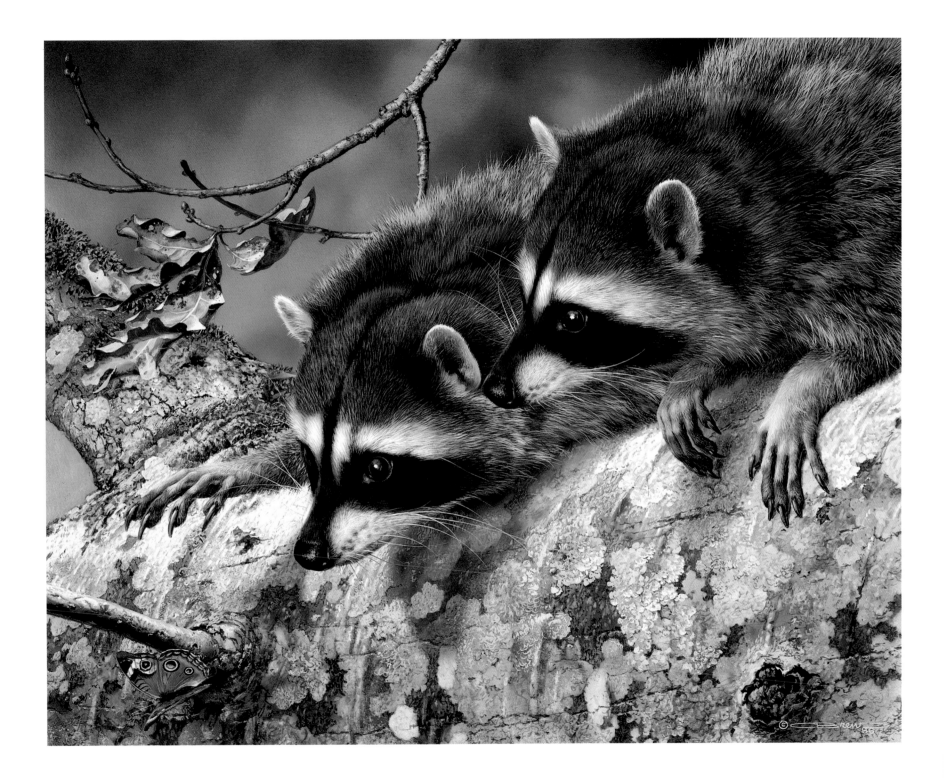

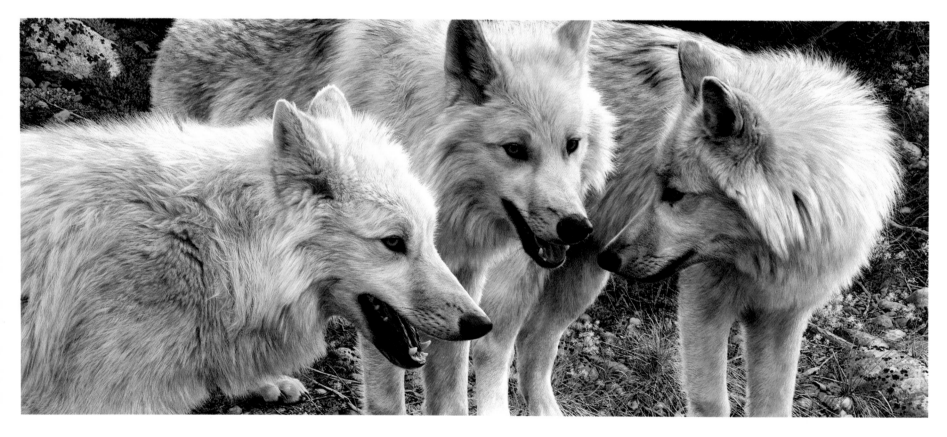

Tundra Summit—Arctic Wolves

17½ x 40⅛", mixed media on board, 1994

I HAD BEEN LOOKING for a good subject for a painting of unusual size for a long time. It is not so common in the classical art world to crop the subject of a painting, but in a long, horizontal piece, one can. I see it as a new vision of composition. Paintings of wolves in landscapes are nice, but they have already been seen so many times. I wanted to concentrate on the spirit of the arctic wolf and feel myself a part of the pack, discussing a strategy for our next hunt. Having fantasies such as these helps to create more uncommon paintings.

Although quite limited in the painting, the background is very important in this scene. It is typical tundra scenery, and it must tell the viewer about the habitat of these magnificent white creatures.

The Companions
20¼ x 28¹⁵⁄₁₆″, gouache on board, 1989

A PAINTER is a privileged being, because in his imagination he can become intimate with the animals he paints. For the few weeks that I worked on this painting, I felt very close to these two wolves, and little by little they became alive. In nature, one can never approach this closely to wild animals, particularly if they are predators.

At one time wolves were found everywhere in the northern hemisphere. But modern man, the wolf's primary enemy—they have no predators—forced the wolf out of Europe and out of northeastern North America as well as most of the rest of the country. In my painting I tried to reintroduce him. The color differences among wolves is a wonderful thing, and it made an interesting contrast for this painting.

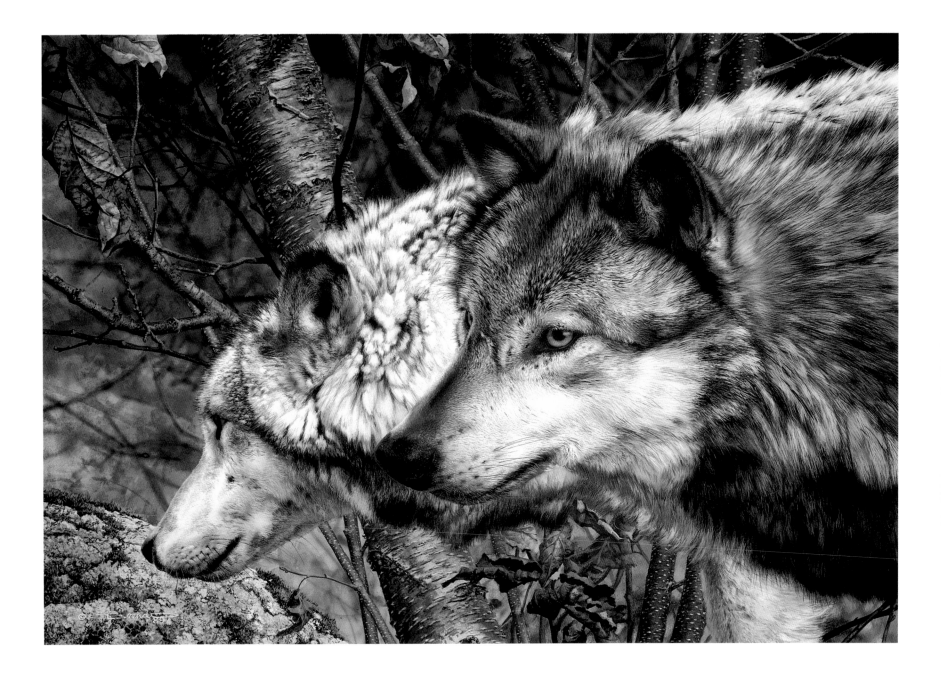

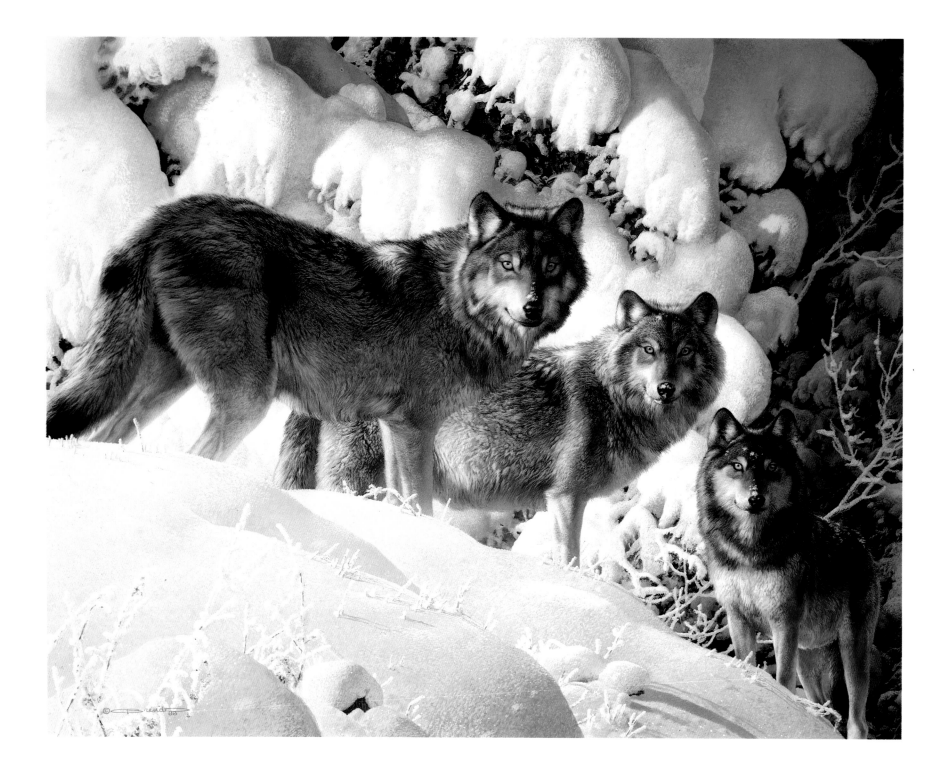

The Long Distance Hunters

27¼ x 33½", gouache on board, 1988

ONCE in his lifetime, every wildlife artist has to make a painting of wolves in the snow. The subject is so attractive that it is difficult not to attempt such a work. Wolves speak to our imaginations. Jack London, author of *The Call of the Wild*, is partly responsible for my fascination with wolves in the north. I've also read stories from Scandinavia and Russia about these wonderful animals. The fact that the wolf *(Canis lupus)* once lived almost everywhere in the northern hemisphere makes it a very special animal. Learning about the long distances they travel and their refined technique of hunting in a group has only increased my respect for them.

Although there are many different color phases among wolves—from white to black—I used their most general "livery" in my painting. As for the setting, I am an amateur cross-country skier, so there is also an element in the work of my love for the beauty of a snowy landscape in weak sunlight. On the right side of the painting I wanted to give the impression of an opening in the snow-covered pine trees so that the wolves, after watching me, could silently disappear that way.

Den Mother—Wolf Family

26⅛ x 36½″, mixed media on board, 1992

WOLVES are among the most interesting animals because of the social rules of the wolf pack. In a pack, only the dominant (alpha) male and female mate and have offspring. The rest of the pack helps to take care of the pups. As wolf pups grow, they are looked after by their mother or a baby-sitter from the wolf pack. They play all the time, learning skills and developing their bodies. Restricted to one area by their guardians, they trample most of the plant life, which then turns yellow during the dry summer. This explains the ocher colors in the background of my painting.

For me, the wolf presents a symbol for the conservation of our wild world. I have great respect for the wolf because it managed to survive even though it was poached and killed for centuries throughout the northern hemisphere, where it lives. I will never tire of painting wolves; there is great satisfaction in rendering that wild glance in their eyes.

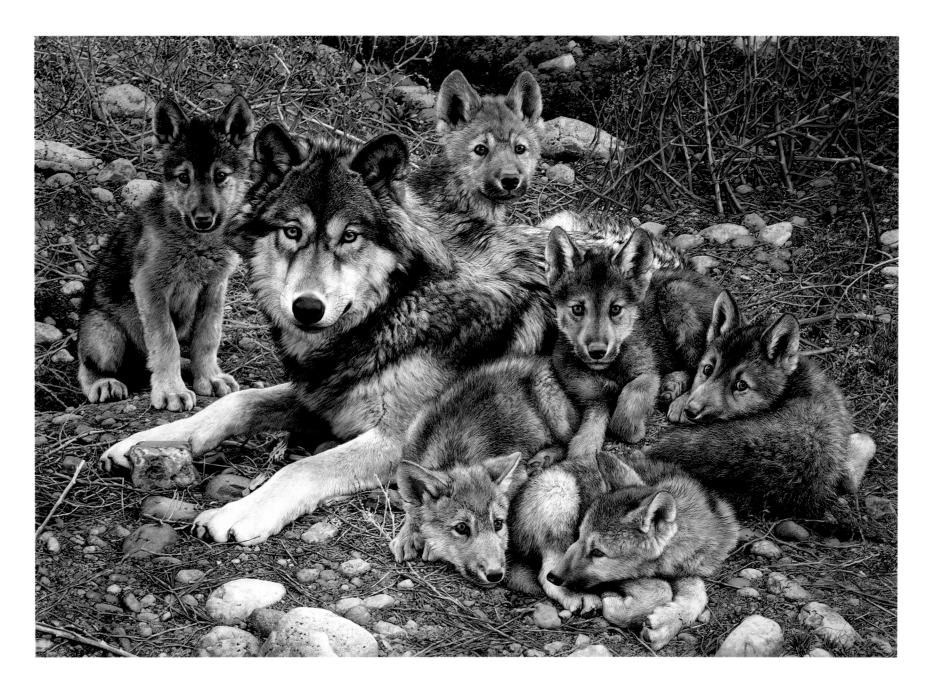

One to One—Gray Wolf

28¾ x 36¾″, mixed media on board, 1991

I HAVE had many different ideas about painting that mysterious creature, the wolf. Recently, I was pleased to learn that wolves will probably be reintroduced to Yellowstone National Park in the future. Because Yellowstone and the wolf have a special place in my heart, I had the idea to combine them in a painting.

On one of my trips to Yellowstone I followed a coyote, the smaller cousin of the wolf, for a long distance. It brought me to one of the most beautiful places I had ever seen in the park. The harmony of the dry grasses and the different colored rocks, ranging from blacks to blues, excited me. Places such as this inspire me, and I am very grateful that the coyote took me there. It is thrilling for me to get inspiration from such encounters in the wilderness.

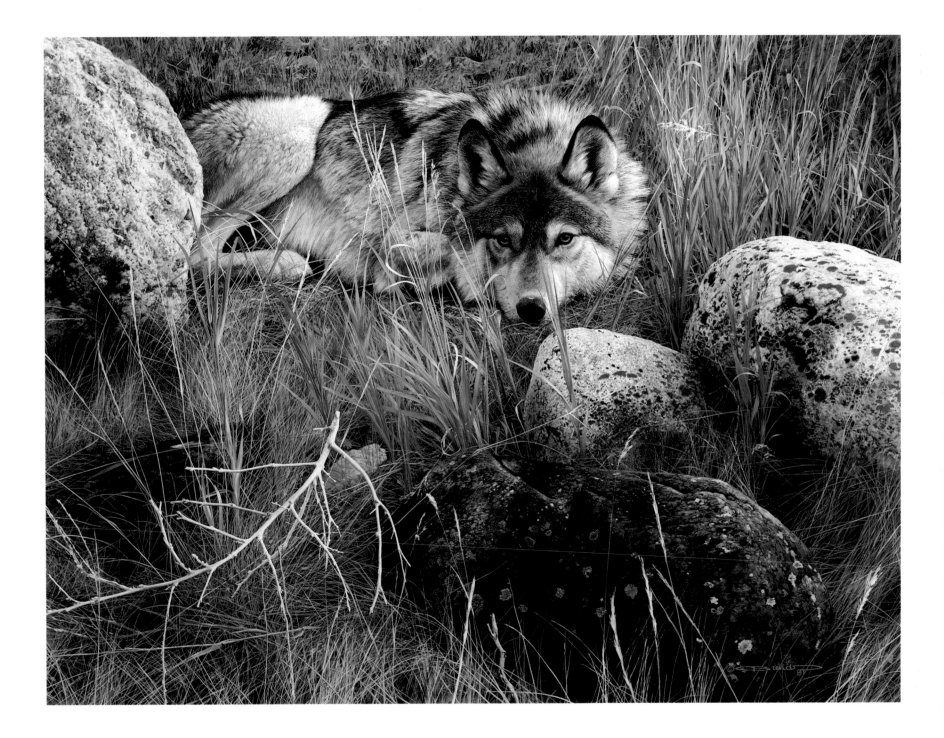

Ghostly Quiet—Spanish Lynx
19¹¹⁄₁₆ x 25⅛″, mixed media on board, 1982

MY CAREER in the United States began with this painting. It was not a coincidence that the first painting I sold there was of a lynx, because the lynx and bobcat of North America are closely related to the Spanish lynx. I had been very fortunate to spot a lynx in Spain, a rare sighting. I only like to paint animals after I have seen them in the light and air of the country in which they live. The place where I saw the Spanish lynx is very similar to some North American landscapes.

When they walk, cats have the appearance of being ghostly; their silent movement and the mysterious feeling they radiate inspired me to choose the title *Ghostly Quiet* for this painting.

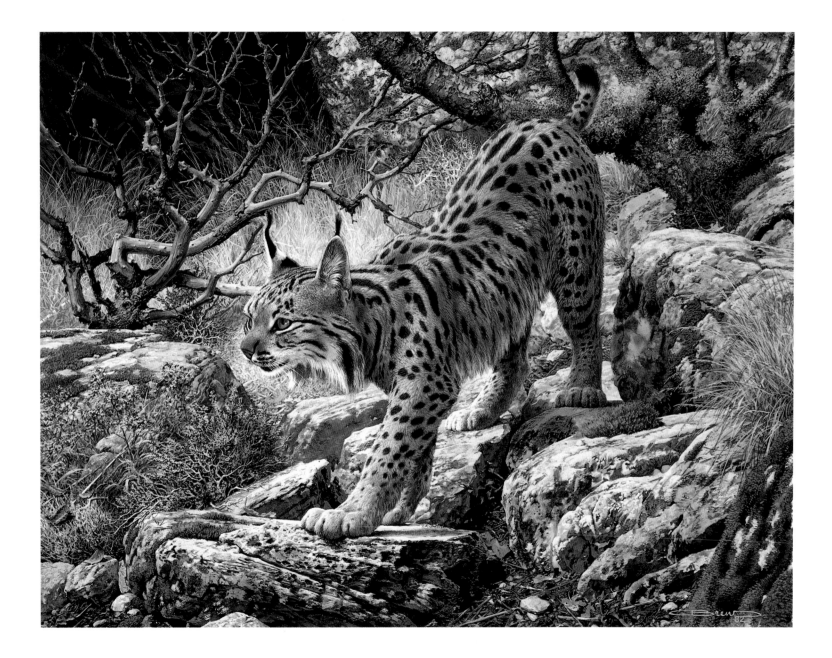

In Northern Hunting Grounds

26¾ x 38⅛″, mixed media on board, 1992

THE ONLY members of the cat family with short tails and black ear tufts are the lynx species. The Canadian lynx is the most impressive member of this family. It has very long legs and thick, oversized feet for walking on the snow that covers its hunting grounds a large part of the year. The lynx's main prey is the snowshoe hare. Some years, when hares are plentiful, the lynx grows fat; but at other times, roughly once in a ten-year cycle, the number of hares declines a great deal. A difficult time then begins for the predator, who must sometimes travel hundreds of miles to find food.

I did not want snow in my painting so that I could paint this beautiful background. An animal in a rocky background forms a great combination for the wildlife artist: the softness of the fur contrasts nicely with the hard rocks. The position and angle in which I show the animal in this work seem to me most elegant and attractive, and I think the composition would also be perfect for a sculpture. It also shows that the white inside of the back legs is the only element that makes the lynx stand out in this kind of landscape.

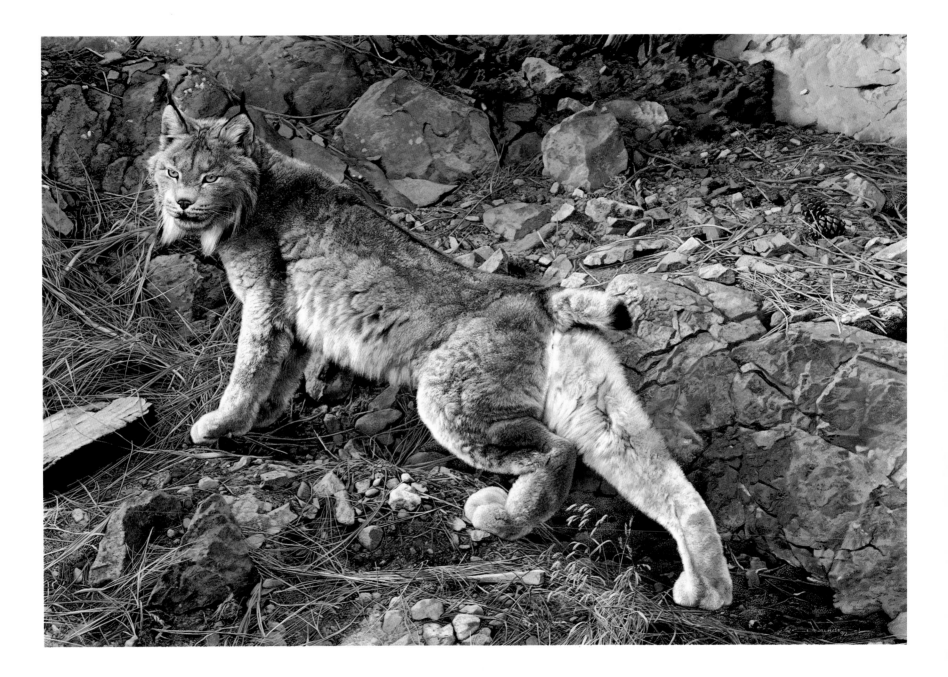

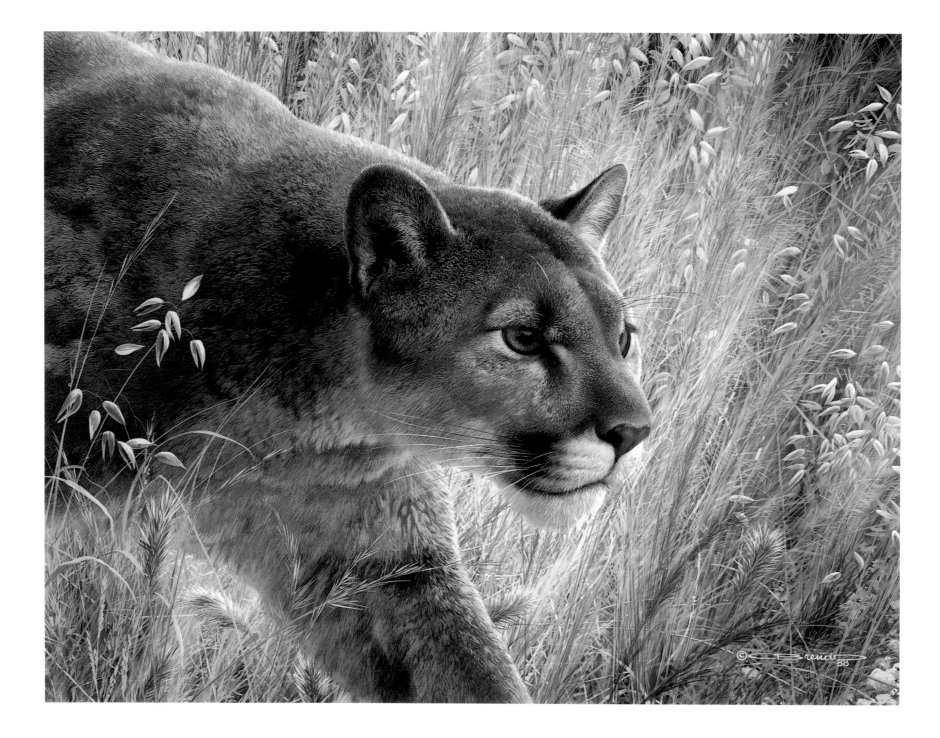

The Predator's Walk
19½ x 25", mixed media on board, 1988

THIS painting expresses my longing to get as close as possible to what I think is one of the most splendid of the big cats of the world, the cougar. The big cats are my favorite subjects, but because I am so fond of the scenery of the northern hemisphere my choice is limited to the cougar, lynx, and bobcat.

The challenge for me in the painting was to depict action. It was difficult to capture the effect of the cougar's elastic walk by only showing a small portion of the animal's body. For the background, I chose high grass because the color complemented the animal. Green mosses, in this case, would not have been good.

To me, one of the most magnificent things in nature is the eye of the cat, and thus it is the most important part of my painting.

Silent Passage

23 x 33¾", gouache on board, 1987

SINCE my childhood I have been impressed by the elegance and suppleness of a cat's walk. As a boy, when I saw a cat crossing our backyard, my imagination began to work, and instead I saw a tiger in the wild. Later, while studying all kinds of books on big cats, it was mainly the cougar that captured my attention, probably because cougars occur in habitats much more familiar to me than the wilderness areas of Asia and Africa. The books of Jack London made the mystique of the cougar even more fascinating to me.

When I first fell in love with the American outdoors, I could not wait to make my first painting of a big cougar. My purpose in this painting was to portray the wildness and intensity of the big cat on the hunt. I got my inspiration in the Roosevelt National Forest in Colorado, where I was guided by artist Amy Brackenbury.

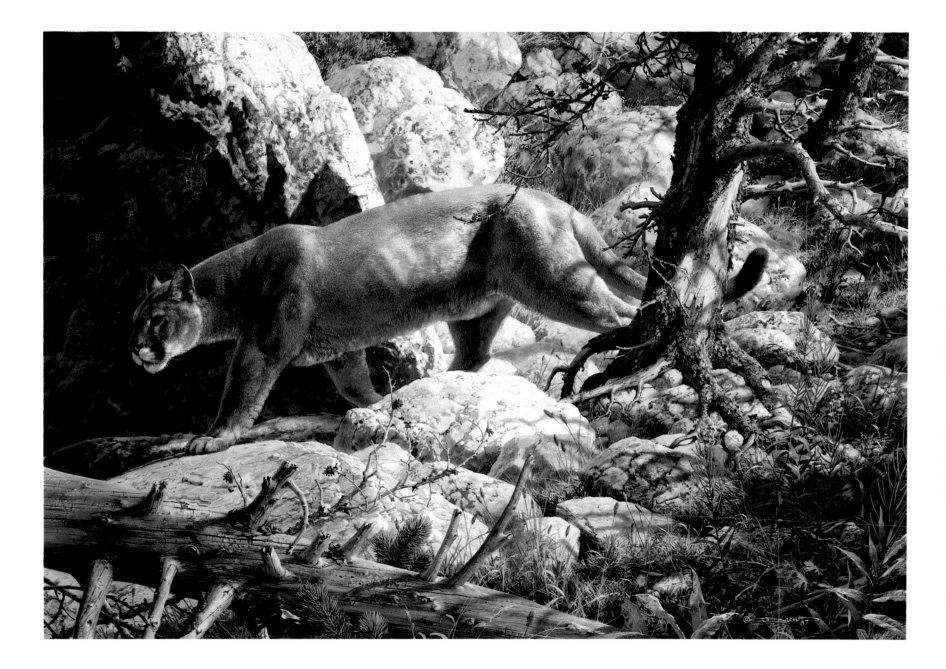

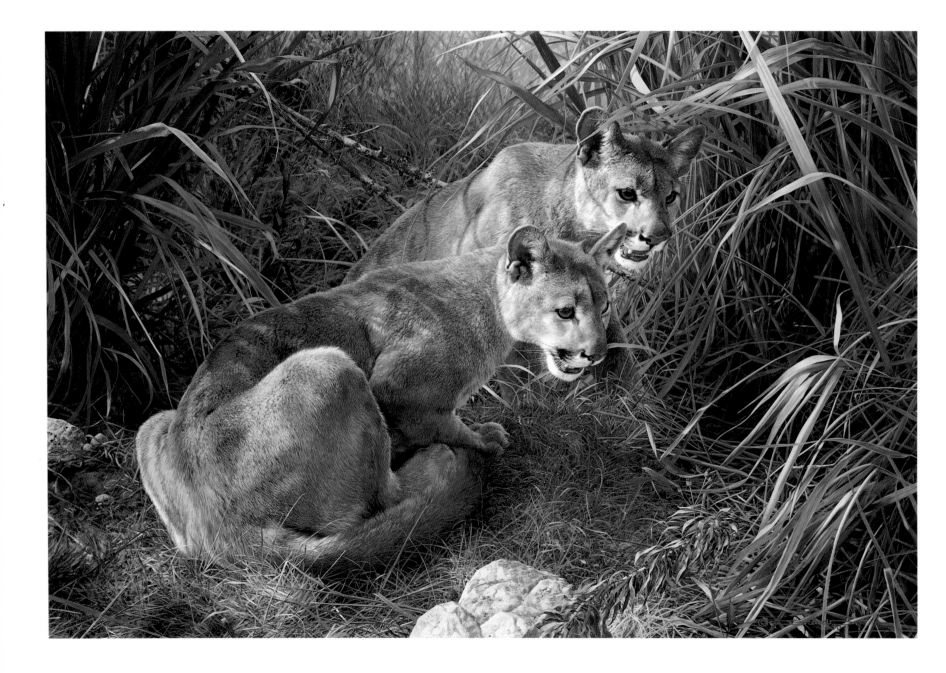

Shadows in the Grass—Young Cougars
25 x 36″, mixed media on board, 1990

O NE OF the most beautiful cats is surely the cougar, or mountain lion. (In Europe, we know it as the puma.) When my father took me to the zoo as a small boy, he always wanted to show me the big cats, lions and tigers, but I was more attracted to the smaller cat, because it reminded me of the cowboy and Indian stories I'd heard. Together with the lynx and the bobcat, the cougar is a true American.

As I grew older and more involved in nature and the out-of-doors, I learned that the cougar is on the decline. Driven or hunted out of its habitat, its range is now reduced to remote areas of the western states, as it has yielded to the pressures of building and development.

My painting shows two cougars about six months old, symbolizing the hope of a bright future for one of the most magnificent creatures of the American wild.

Rocky Camp—Cougar Family
27 x 36¾", gouache on board, 1993

THIS painting is based on the nicest fieldwork I ever did. For the first time in my career, I could control the situation. I had the painting already in my mind. I wanted rocks in the background. The only thing missing was a model for the texture of the fur in the light that I wanted. At a game farm in California, where they train animals for movies, I got the best opportunity. There was a rocky place behind the farm where a docile, well-trained female cougar could lie down exactly where I wanted her—one couldn't dream of a better situation.

The cougar's fur was a little rough, exactly the way a mother's fur gets when the cubs play with her a lot. The vegetation was scarce, but interesting for my painting. Rocks, vegetation, and animal, for the first time everything in the same place. Everything except the cubs. This required careful study. Just like children, cougar cubs all look different: their spots vary, sometimes very dark and pronounced, sometimes vague and light. Ear size and form also vary a good deal, depending on the subspecies of the animal.

Cougars usually have three cubs, but can have up to six. I painted four, to get a nicer composition. It's a delight to take the cubs in your arms. I picked out my favorite types, and after lots of sketches and tryouts for compositions, the painting was born. Three months of work—the longest time I ever spent on a painting.

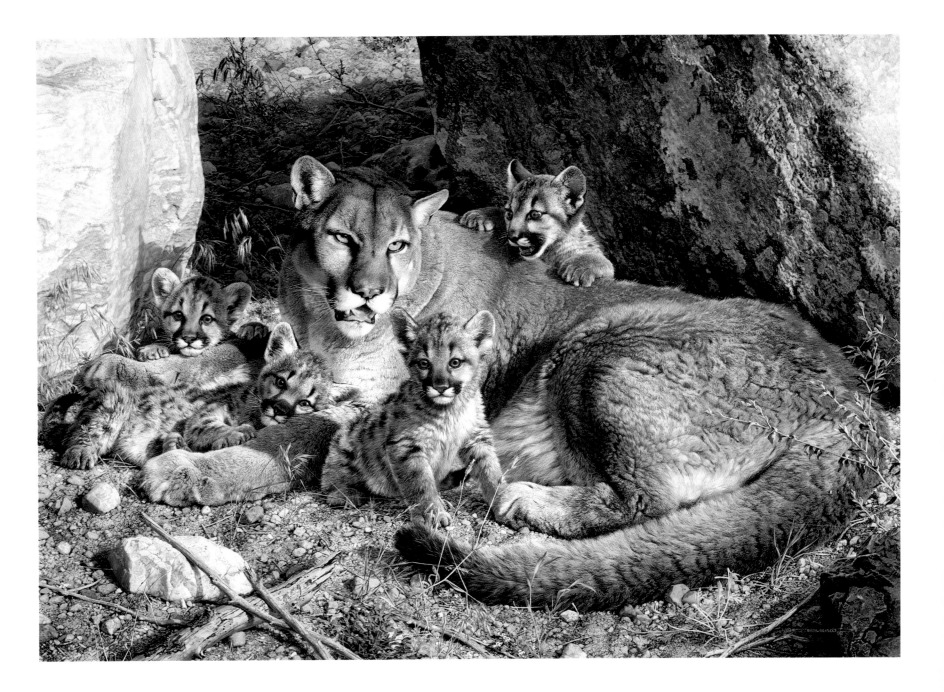

Colorful Playground—Cottontails

22½ x 15″, mixed media on board, 1986

I N EUROPE, dandelions are consumed in salads for their nutritional benefits. I am very interested in edible plants, and I am always on the lookout during my travels for the types of plants that I am familiar with from Europe. On one of my first trips to North America, I was pleasantly surprised to discover that dandelions are common here as well.

Since the dandelion is both American and European, I decided to do a painting using them, but I wanted a scene with a mammal that was also found on both continents. The eastern cottontail and the European rabbit are quite similar, especially when they are young. Even though the painting of plants requires a strong discipline to achieve accurate detail, the inspiration for this piece came quite easily.

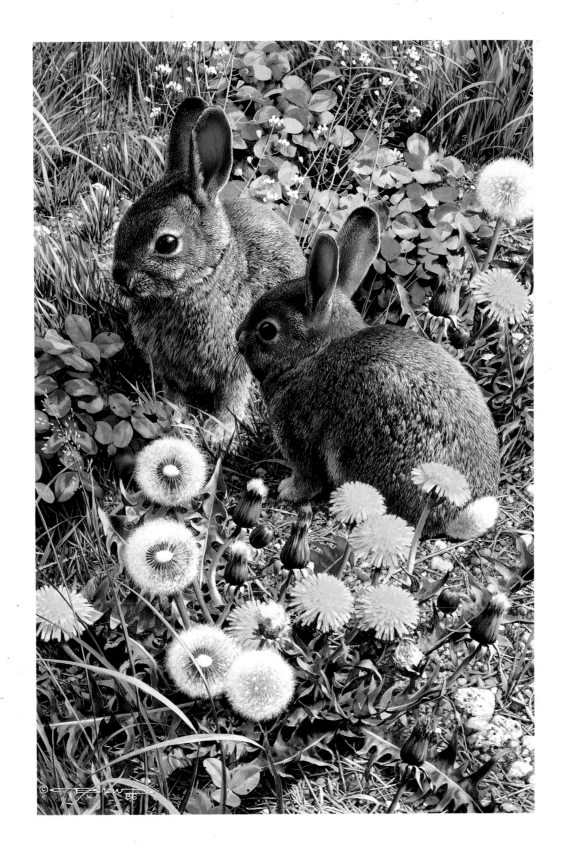

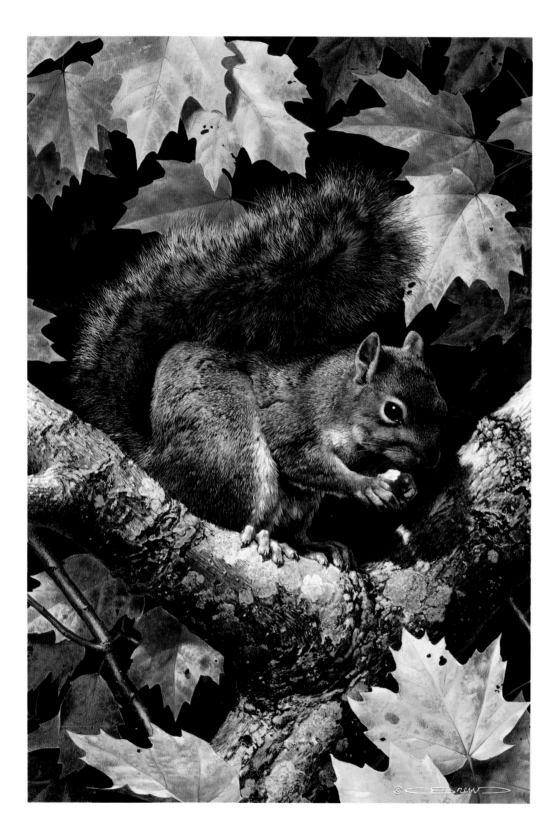

Golden Season—Gray Squirrel

20¾ x 14¼", mixed media on board, 1985

I ALWAYS enjoy watching squirrels, and their acrobatic antics often make me forget the time. It always amazes me how these smart little creatures can climb a tree trunk and disappear from sight. Then they reappear as fast as they disappeared. It's almost as if they are playing a game and asking, "Do you want me to climb higher?"

In cities and suburbs, squirrels are quite tame and easy to observe. In the forest, however, this is not always the case. Squirrels are easy to see in open pine trees, but they are more difficult to observe in broad-leaved trees. But just as you are about to give up your search, a squirrel may appear, enabling you to adjust the binoculars in time to enjoy the sight of the squirrel nibbling on a seed.

Nature created this scene, but as an artist I couldn't resist capturing in a painting the gray squirrel contrasting with the colorful leaves of fall.

Harvest Time—Chipmunk
18⅛ x 8⅜", mixed media on
paper, 1986

CHIPMUNKS are among
my favorite subjects. I am
very attracted to their fur,
a mixture of gray and brown
combined with the contrast of
black and white stripes. I love to
see them playing among the
rocks. Under pine trees, the dead
needles and stones have almost
the same combination of colors,
so these smart little rodents can
usually be seen only when they
move. I can spend hours observ-
ing them and I never get tired of
watching their funny games.

Although I really enjoy
painting big game animals, small
ones give me the opportunity to
paint the interesting details of the
forest floor, such as old pine
cones which vary from gray to
brown as they get older, or the
surprising designs of the lichens
and mosses on the stones. Pine
forests are a great source of
inspiration, and they bring back
fond memories of my youth.

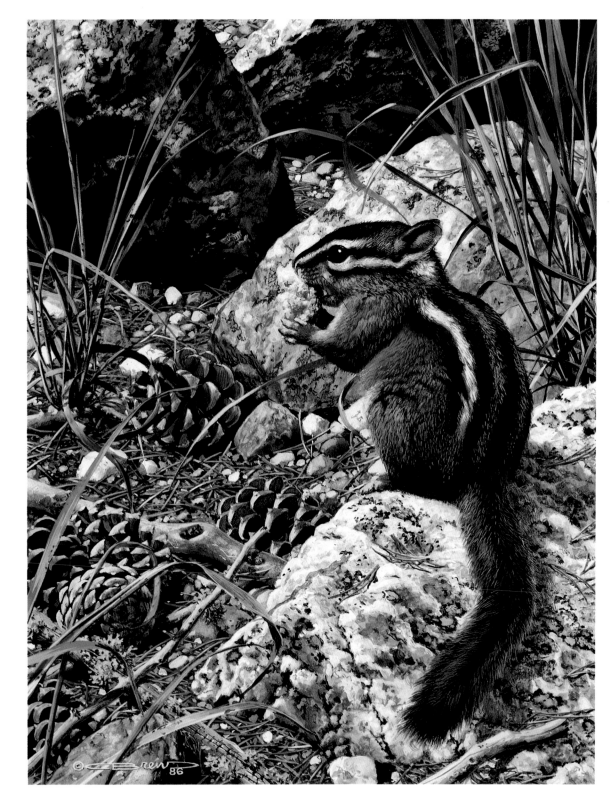

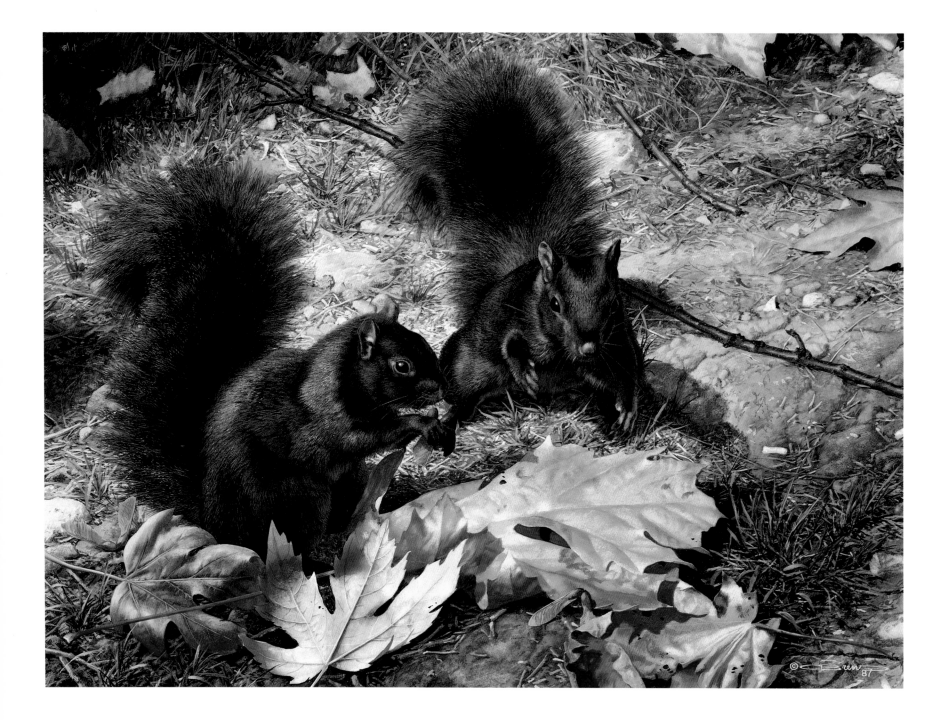

Northern Cousins—Black Squirrels
16 x 20″, gouache on board, 1987

BEING a lover of squirrels and knowing a lot about them, I was surprised to see a completely black squirrel on a field trip in the Vancouver area. As I continued traveling I saw many of them and I couldn't believe my eyes.

Until then I had never come across any mention of black squirrels in any mammal field guide. After contacting some biologists I learned that black squirrels are just gray squirrels in a black coat. One can compare it with the phenomenon of the big, black cats such as panthers, jaguars, and servals—a question of melanism.

Black squirrels are only found in the northern United States and Canada, which explains my title, *Northern Cousins*. Doing this painting was very enjoyable. The harmony of the black squirrels and the fall maple leaves was irresistible.

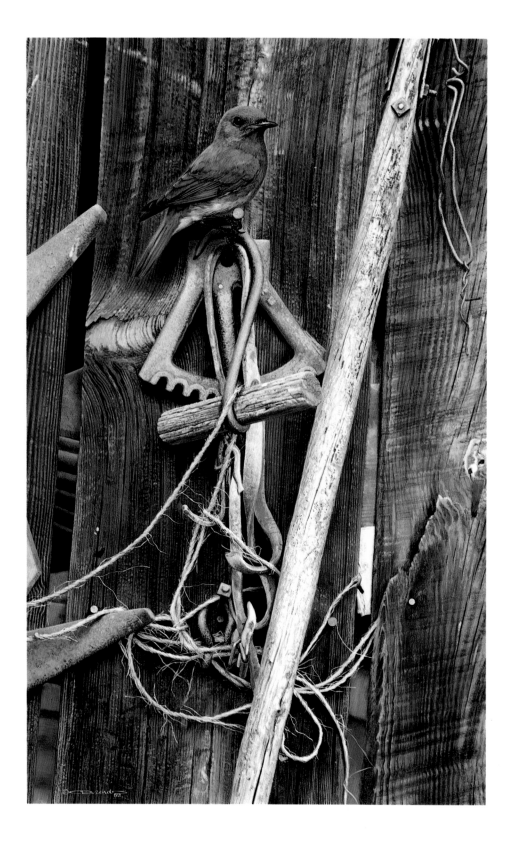

On the Old Farm Door
29⅛ x 18″, mixed media on board, 1989

RURAL areas have a special place in my heart, probably because my mother was from a farming family. As children, we used to spend our school vacations on one of my uncle's farms, and we often helped out in the old-fashioned way of harvesting using the big workhorses.

Now as I travel around North America, I can't resist looking into old barns. Most farmers don't understand why old farm buildings are so interesting to me. For them, a barn is only an old utilitarian structure, but for me, they are a world full of life and color. There are always things to see in barns that remind me of my childhood. Many times I will find an unexpected visitor, such as a wild bird or small mammal. One time, when such a visitor happened to be a bluebird, I thought its colors fit very well with the colors of the wood construction of the barn and I decided to do this painting.

The Nesting Season—House Sparrow

23½ x 15¾", mixed media on board, 1990

SINCE my childhood, horses have been among my favorite animals. During school vacations on my uncle's farm in Holland the big workhorses became one of my favorite subjects to draw. The smell of horse stables still reminds me of my youth.

On the farm there were lots of other animals in the stables that caught my attention, such as mice, spiders, swallows, and sparrows. The birds found good nesting places in the farm buildings. I always enjoyed watching them build their nests. It was fun to see them gathering the materials and working on the nest all day long.

Most people don't pay much attention to sparrows because they are so common, but if you take a good look at them, you will see that they are worthy of being painted.

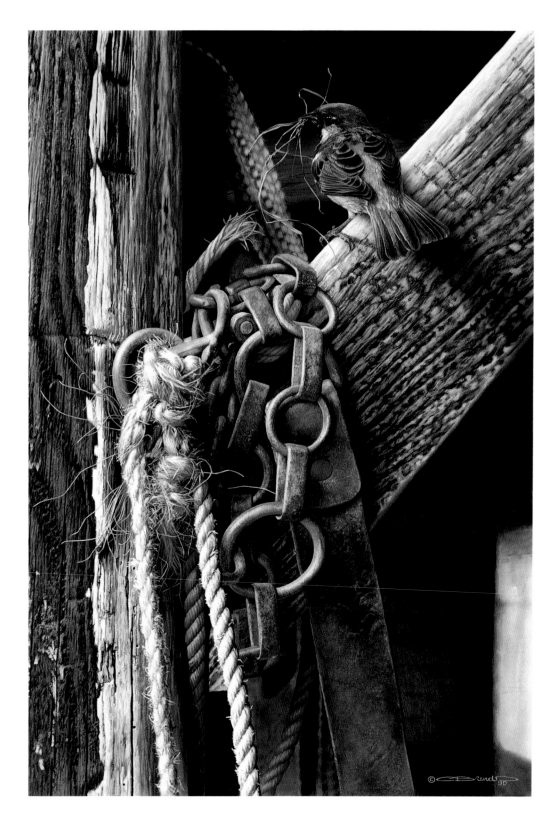

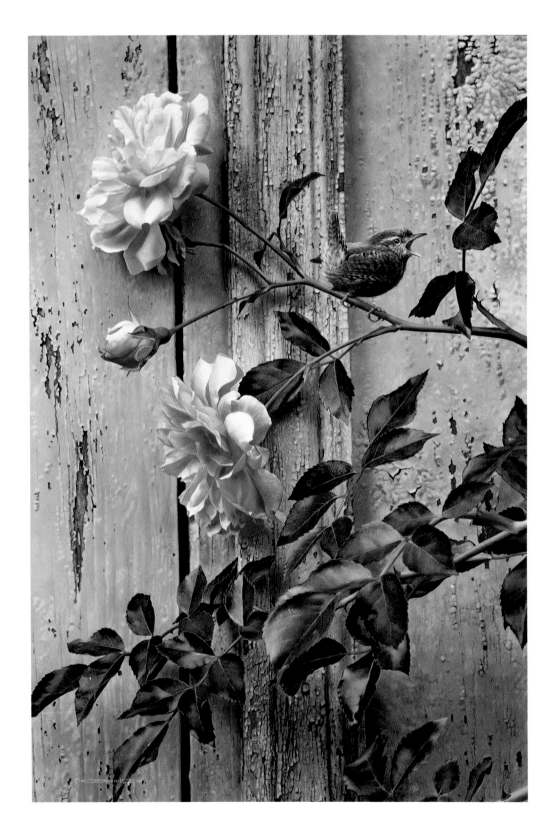

Summer Roses—Winter Wren
28½ x 18½", mixed media on board, 1993

OLD PROPERTIES are always attractive to me because of the big trees and dense vegetation. Being around dense vegetation means seeing or hearing the winter wren. On a trip to France, at the entrance of a big abandoned property, I saw a beautiful wild rose garden beside an old forester's house. And indeed, a little winter wren was singing out its joy of life. For a few moments it posed on one of the roses, but not long enough for me to take out my camera and focus. I did take photographs, however, of several of the roses and the old forester's house door, a perfect background. The idea settled in my mind and I couldn't wait to do this painting.

The winter wren, a true American, is the only wren that made it across Alaska into Europe, and it has spread out all over the continent. Smallest of the wren family, it is an incredible singer.

NEW RELEASES BY CARL BRENDERS

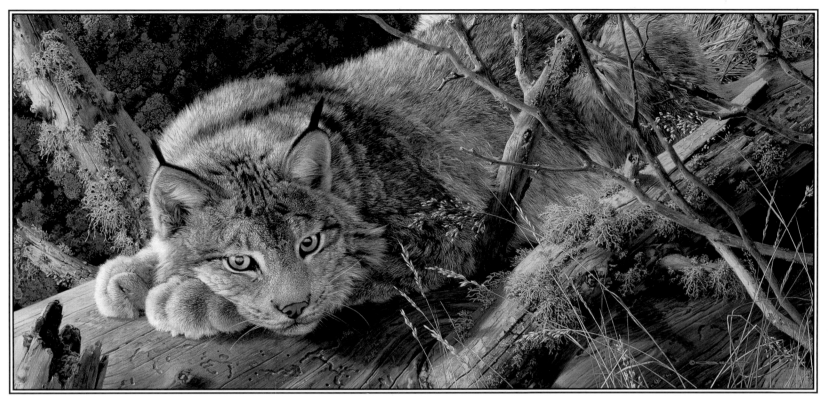

TAKE FIVE – CANADA LYNX $245.00 1,500 s/n* 15" x 31-1/4" (ABS85) Published from a mixed media painting. *plus 76 Artist's Proofs

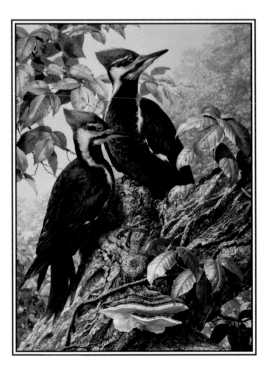

DALL SHEEP
PORTRAIT
$135.00 950 s/n*
9" x 12" (ABS64)
Published from a
gouache painting.
*plus 76 Artist's
Proofs

FOREST
CARPENTER –
PILEATED
WOODPECKERS
$195.00
1,950 s/n*
25-7/8" x 18"
(ABS53)
Published from
a mixed media
painting.
*plus 56 Artist's
Proofs and 20
Publisher's Proofs

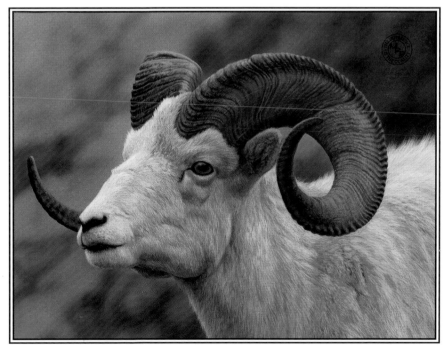

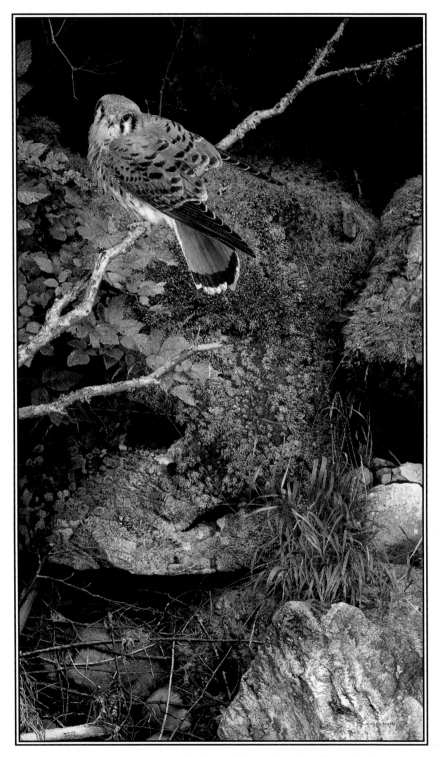

RIVERBANK KESTREL $225.00 2,500 s/n* 32-1/2" x 19-1/8"
(ABS84) Published from a mixed media painting. *plus 76 Artist's Proofs

The Limited Edition Art of
CARL BRENDERS

Come Closer to Nature Than Ever Before!

Carl Brenders takes you closer to wild animals than you've ever dared to venture. His art is a testimonial to his love of nature, evident in his mastery of its every detail — not a whisker, not a twig, not a feather is overlooked.

Explore the rivers, mountains and woods of North America with this Belgian artist and discover creatures from the friendly to the ferocious. The limited edition art prints of Carl Brenders are available at your authorized Mill Pond Press dealer. Also available are a book, *Wildlife: The Nature Paintings of Carl Brenders*, a fascinating video entitled "Windows into Wilderness: A Portrait of Carl Brenders" and tee shirts featuring the image *One to One – Gray Wolf*. To order, see your Mill Pond Press dealer or call the number listed below.

Mill Pond Press

800-535-0331

© 1994 Mill Pond Press, Inc., 310 Center Court, Venice, Florida 34292-3500
Distributed in Canada by Nature's Scene, Mississauga, Ontario L5T 1R9
All artwork © Carl Brenders UNITED STATES Printed in U.S.A. 9/94

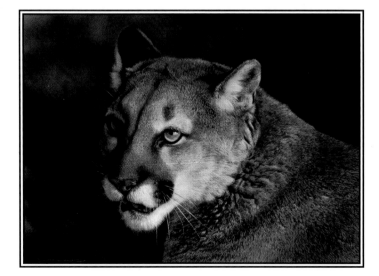

CLOSE-UP–COUGAR $110.00 1,250 s/n* 8-3/4" x 11-5/8"
(ABS86) Published from a mixed media painting. *plus 76 Artist's Proofs

Apple Harvest

18½ x 13½", mixed media on board, 1988

THE INSPIRATION for this painting came from my own backyard, where we have several old apple trees that produce a type of apple that we can't buy in the stores anymore. Usually you can find a lot of fallen apples in an orchard, especially if they are organically grown. The apples have a good taste, but they don't last very long on the ground because of the worms.

To make the apples last a bit longer, I put them on an old table where we have lunch when the weather is nice. One day, the colors and shine of the apples attracted me particularly, and when a European sparrow came to rest on the table for a few moments, I decided to capture the scene in a painting. But I chose to depict a junco, a typical American bird whose plumage better suited the colors of the apples.

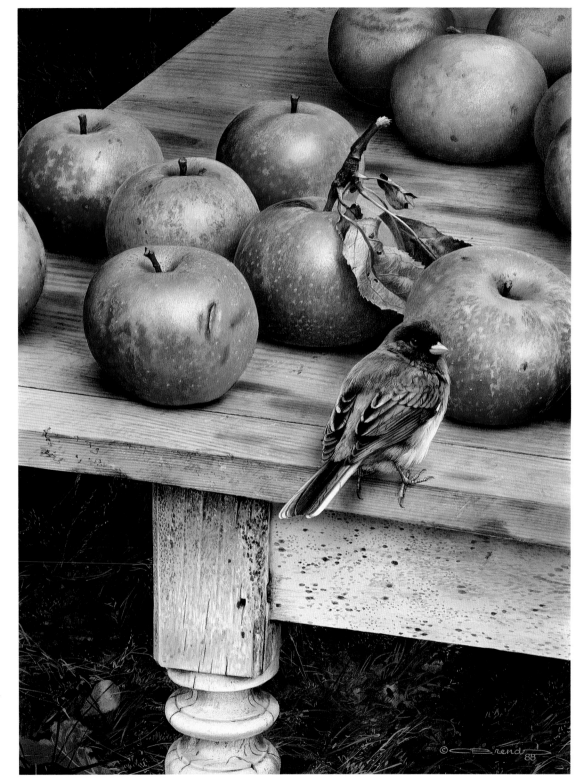

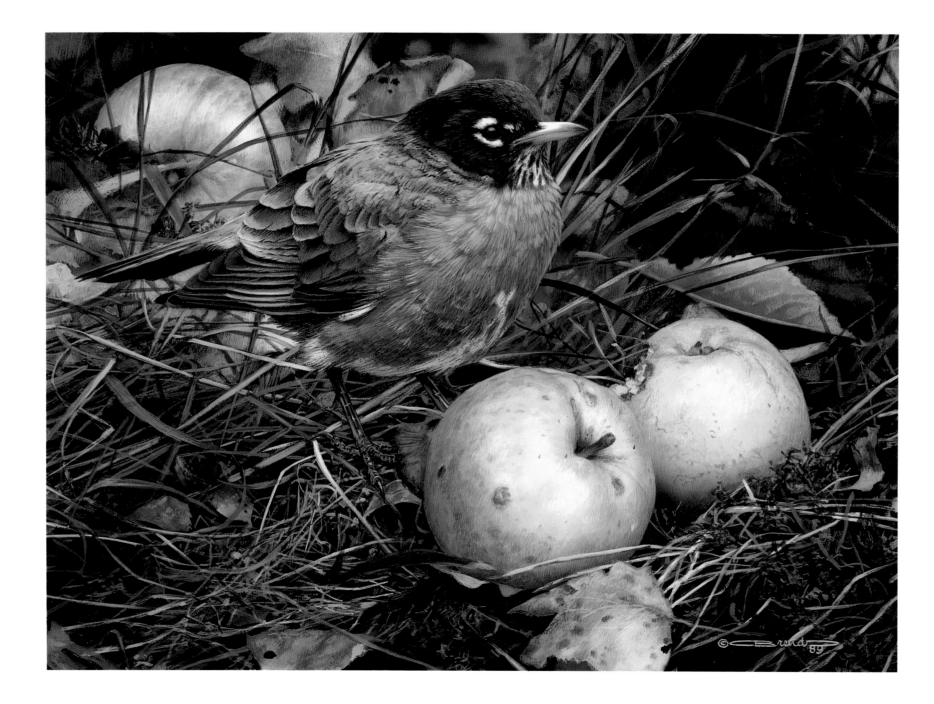

The Apple Lover
9¹/₁₆ x 12³/₁₆", mixed media on board, 1989

THE IDEA for this painting came to me as I watched European blackbirds eating the fallen apples in my backyard. In the autumn, when it gets colder, the thrushes, who normally feed on berries and insects, seem to find the apples an easy food supply. They eat them and stay around for the most part, chasing other birds away from "their" apples.

Both the European blackbird and the American robin are members of the thrush family. I was very happy to learn that both species exhibit almost the same behavior. Although the majority of American robins migrate south, those who stay longer do eat apples and love them. So I thought *The Apple Lover* was a good title for my painting. Since I spend a lot of time in the United States, I have become as familiar with the robin as with the European blackbird—both are good singers and apple lovers.

Migration Fever—Barn Swallows
20½ x 31½″, gouache on board, 1987

A T POINT PELEE, Ontario, one of Roger Tory Peterson's twelve "hottest" birding spots, I had an extraordinary opportunity to observe the behavior of a group of barn swallows for hours. They were building their nests in a big tower that overlooked an especially nice swamp. As I climbed the tower stairs, I came very close to the barn swallows; they did not seem to be disturbed by my presence.

Crossing the rural Ontario landscape in springtime, I saw lots of old barns with swallows everywhere. Seeing them, I was reminded of my youth, when I would see the little birds gathering before migration. I imagined all the activity there would be in Ontario in the autumn when the barn swallows would teach their young to fly. Some of these swallows had reddish-brown breasts; others had much lighter colored breasts. I chose to paint the lighter variety: they are similar to the European species.

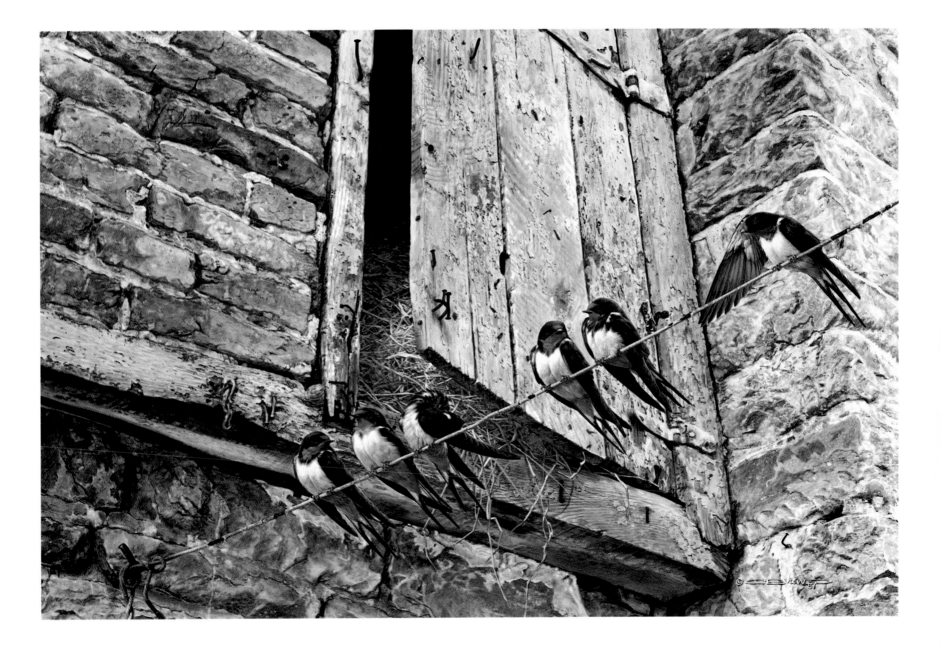

Steller's Jay
$17^{13}/_{16}$ x 12", mixed media on board, 1988

ONE OF the most attractive birds in the Belgian forests is the European jay. It is a big, beige-brown jay with a few bright blue feathers in its wings. These blue plumes contrast so beautifully with the beige of the body and the black of the rest of the wings that it makes them very special guests in the backyard.

As I learned about North American wildlife, I found that several species of blue jays exist here and that excited me. The classic blue jay of the eastern United States is one of my favorites, but the Steller's jay, so typical of the Rockies and the West, is even more attractive because of its deep blue body and dark brown head. I will never forget the excitement I felt when I saw one for the first time in Yellowstone National Park. I also fell in love with the yellow lichens that are everywhere on the old, dead pine trees in the West. The harmonious combination of the yellow lichens the blue bird begged to be painted.

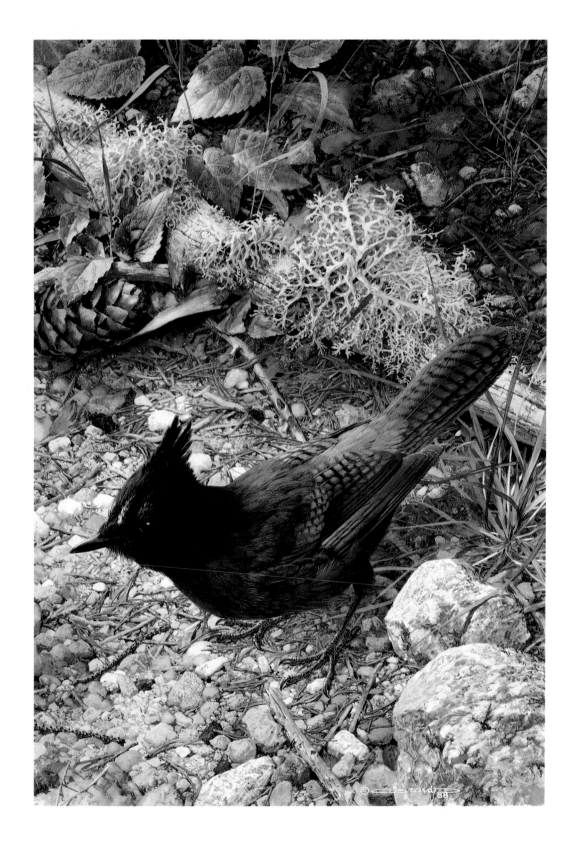

Talk on the Old Fence
25¹⁵⁄₁₆ x 33½", mixed media on board, 1988

A S AN artist, walking through the forest in the colorful season of fall, I become excited when I see all the combinations of yellow, orange, and red contrasting with the green mosses and lichens and accentuated by the dark brown of the rotting wood.

It becomes a real feast for a painter, especially if he is from Europe, where autumn is less colorful, when into this colorful world there suddenly appears a blue bird with a black "necklace" and white spots. Where I live, none of the birds have completely blue-colored plumage. When I saw this old fence on a property in southern Ontario, the idea came to mind to use it for my first blue jay painting.

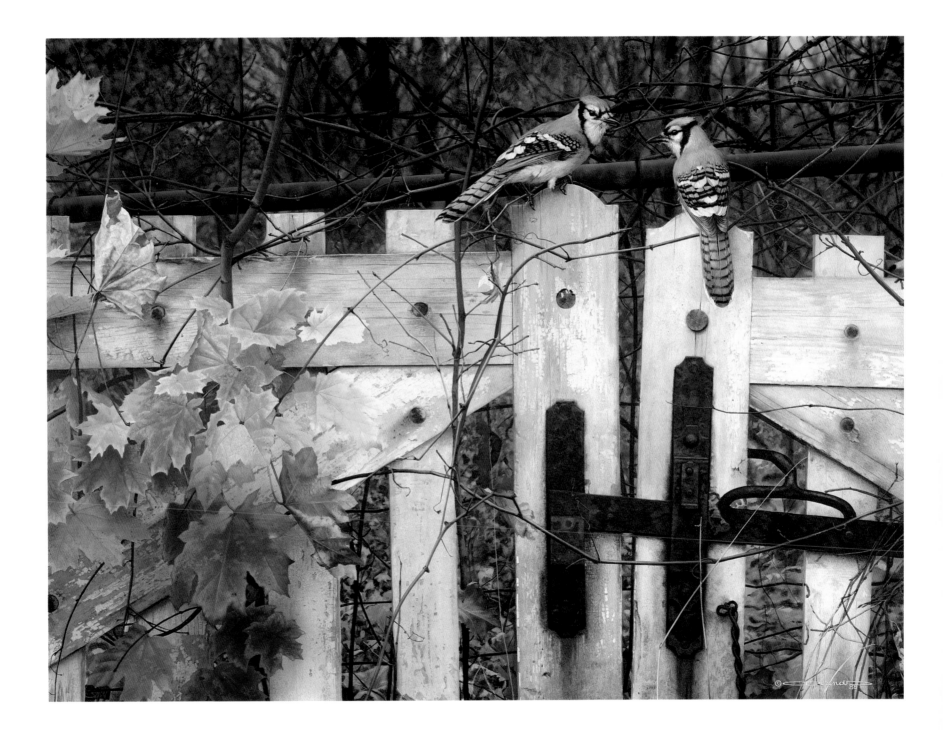

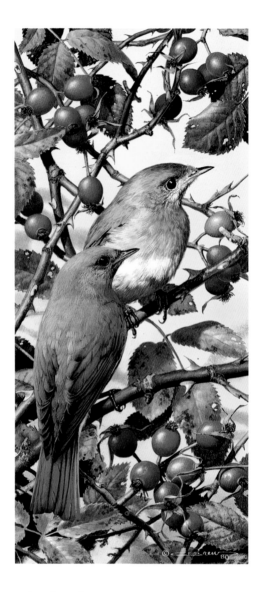

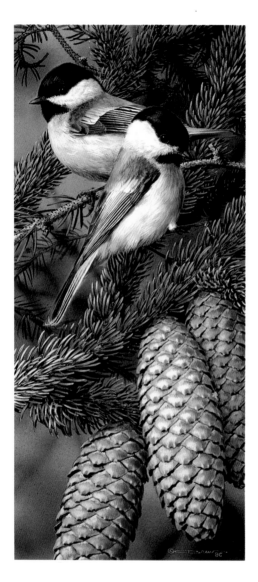

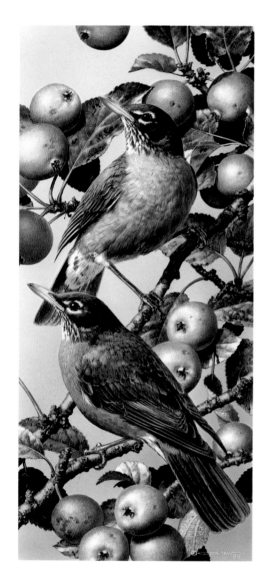

Bluebirds
13¼ x 5⅞″, mixed media on board, 1986

Black-Capped Chickadees
13¼ x 5⅞″, mixed media on board, 1986

Robins
13¼ x 5⅞″, mixed media on board, 1986

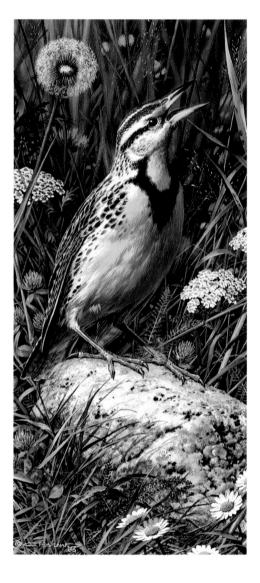

Meadowlark
13¼ x 5⅞", mixed media on board, 1986

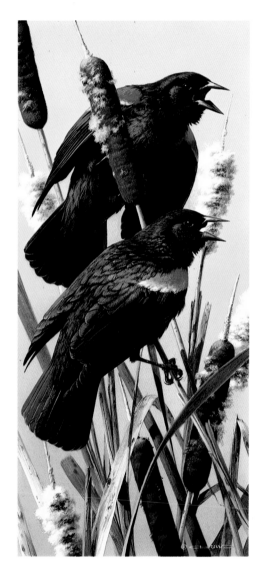

Red-Winged Blackbirds
13¼ x 5⅞", mixed media on board, 1986

ONE OF MY impressions of the American countryside is that it is so expansive that one feels compelled to explore for hours in order to take in all its beauty. On my field trips, I am always overwhelmed by the peace and quiet of the countryside. I often hear the cheerful—and familiar—song of a bird off in the distance in a grassy meadow.

Much to my delight, many of the European species of birds have American counterparts. My first encounters with American birds are always exciting to me. As I continue studying the American "cousins," becoming better acquainted with them, I feel more and more comfortable painting them. American songbirds are familiar to me now, but it took a lot of field research to be able immediately to spot the differences from the European species. Many times the songs of the cousins are similar; they are songs I know from the forests and meadows of Europe.

Plants and herbs commonly found in meadows and old hay fields in Europe are also found in the U.S.; I use them in my paintings whenever I can. I enjoy the harmony of the color combinations of the birds in their natural surroundings. I always want to capture a moment in my painting—the different effects of light and the beautiful contrasts of colors and textures.

Shoreline Quartet—White Ibis
24¾ x 36⅜", mixed media on board, 1990

I HAVE loved the beach since I was a child. I used to play in the waves for hours. The power of the water impressed me, and the transparent turquoise color of the rolling waves always gave me a thrill. I am still fascinated by the way the waves spread out on a beach with all the little bubbles, then slow down and run back, only to be overlapped by another wave. The tremendous feeling of light and space on a beach is wonderful. It is one of the places where I really feel alive, especially when I am in close contact with living creatures around me. At the seashore, those creatures are mostly birds attracted by an abundant supply of food.

For this shoreside scene, I chose the ibis because its colors suit the color of the water—the red of their bills and legs is very important. Their elegant way of foraging brings a poetic element to the painting.

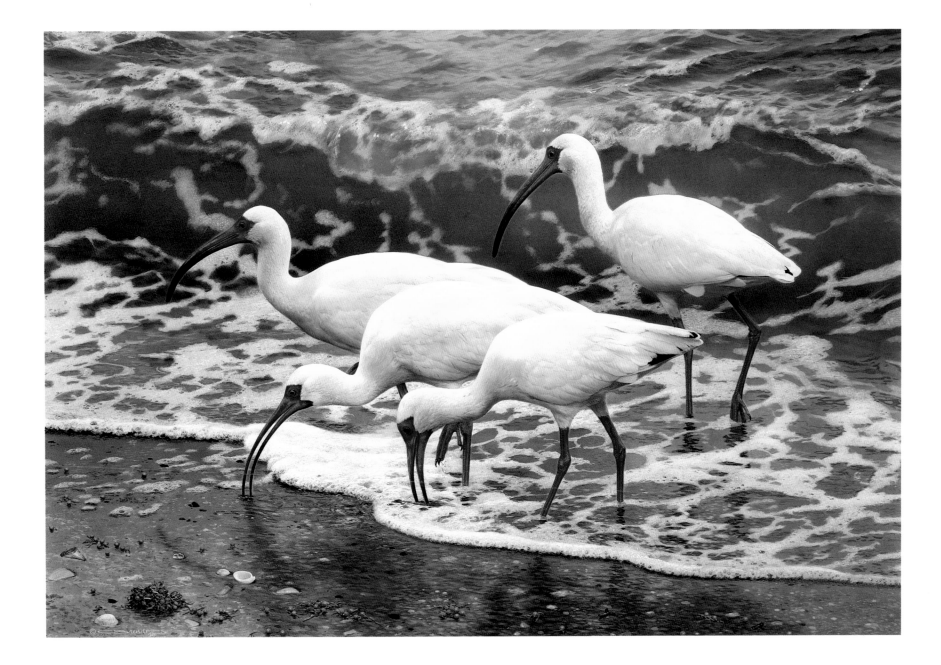

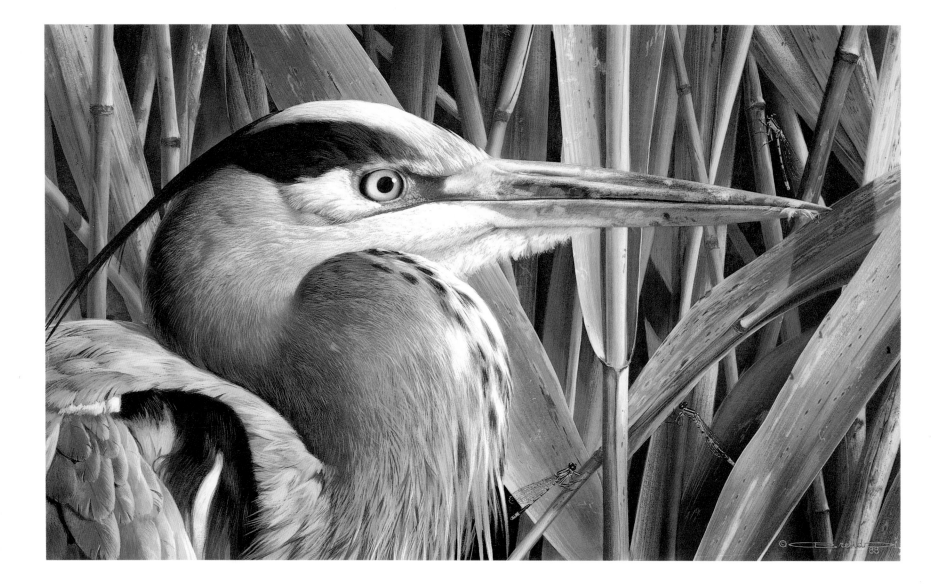

Lord of the Marshes
12½ x 20″, mixed media on board, 1988

THE marshlands of Europe and North America are quite similar. Many of the same plants and animals that we have in Europe are also found in North America. The same reeds we have in Belgium, I found in Maine. I saw arrow grass and cattails growing on both continents. Rails, gallinules, egrets, mallards—we have them, too.

The scene of this painting could also be in Europe, including the little dragonflies. I was attracted to the variety of colors in the old and young reed plants and decided to use them as a background for my painting. And as I felt it needed some blue, I added the blue dragonflies.

One of the most interesting birds for me is the blue heron. This lonely fisherman is so well adapted. It can stretch its plicated neck in a second when catching a fish, like an arrow launched from a bow. Even though the heron may appear to be asleep, its alert eyes catch every movement in the water.

Island Shores—Snowy Egret
24¾ x 34″, mixed media on board, 1992

I FEEL very fortunate that my print publisher is located on the Gulf Coast of Florida. My trips to the United States mostly begin with a visit there; I sign my print editions and always look forward to a stay. In the mornings I walk on the beach near the charming little apartment I use, which is situated on a kind of rocky cliff at a place called Island Shores. For a bird lover, this is the perfect place to be. Herons, egrets, cormorants, pelicans, and other birds are all around. Every morning, at a certain spot on the beach, I see snowy egrets foraging at the shoreline. The early sunlight on the white feathers of those beautiful birds and the movement of the waves is a delight each day. For several years, this lovely place with all its bird life has inspired me so much that the idea came to me to title this painting *Island Shores*.

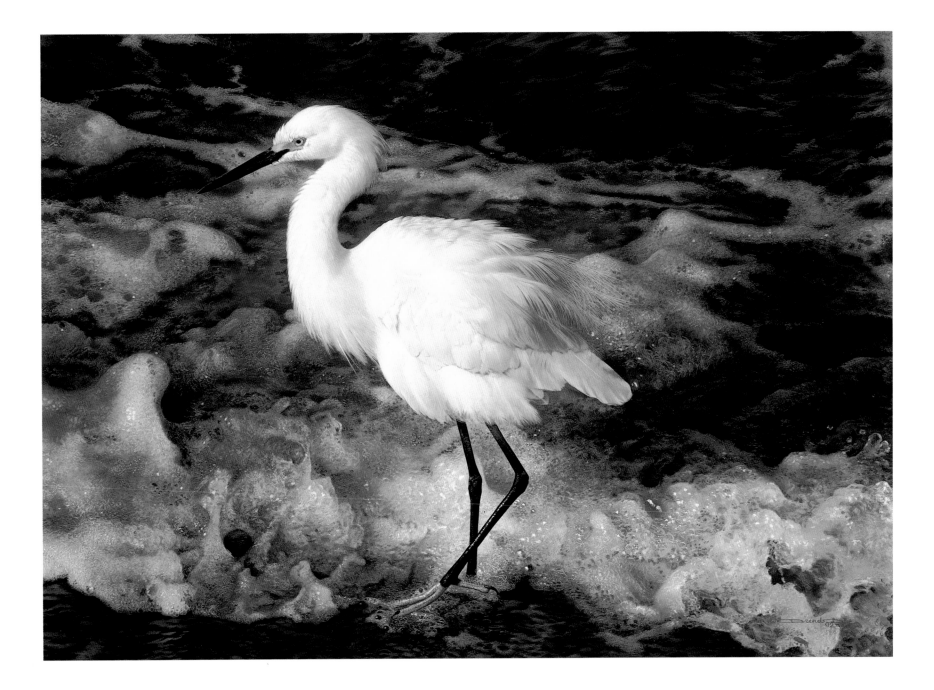

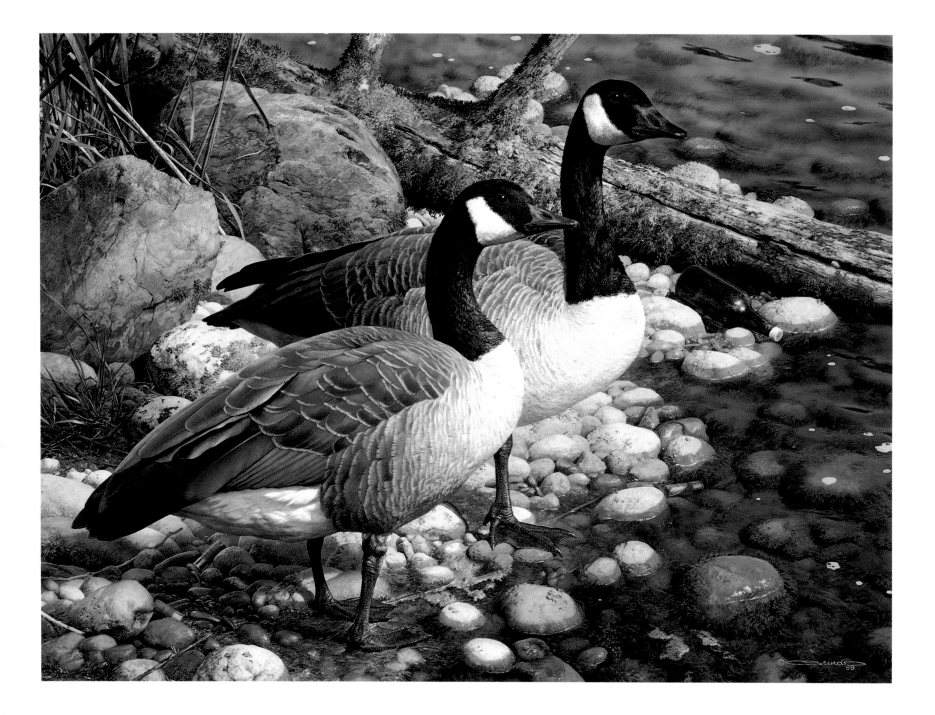

The Survivors—Canada Geese
25 x 33¼", gouache on board, 1989

WETLANDS and shorelines have always been very attractive places to me. The variety of wildlife found in and around the water always guarantees adventure. It is a sensational experience to be there when big flocks of geese and ducks land on the lakes and marshes.

Since my childhood, more and more Canada geese have been seen in Europe; it has become quite a common bird on our continent. Among all our "imported" species, what we call exotic species, Canada geese are now the most numerous. They look more elegant than most European geese species; the Canada's black-and-white neck and head are very attractive. I feel fortunate these days to be able to see them without having to travel all the way to North America.

In addition to celebrating the beauty of the Canada goose, I wanted this painting to alert people to the danger posed by all the lead shot that lies on shoreline, marsh, and lake bottoms after generations of duck and goose hunting. Many foraging geese are poisoned by this lead. I thought this was a good opportunity to ask my collectors who are hunters to switch over to one of the nonpoisonous kinds of shotgun shells to help keep the environment clean for the future.

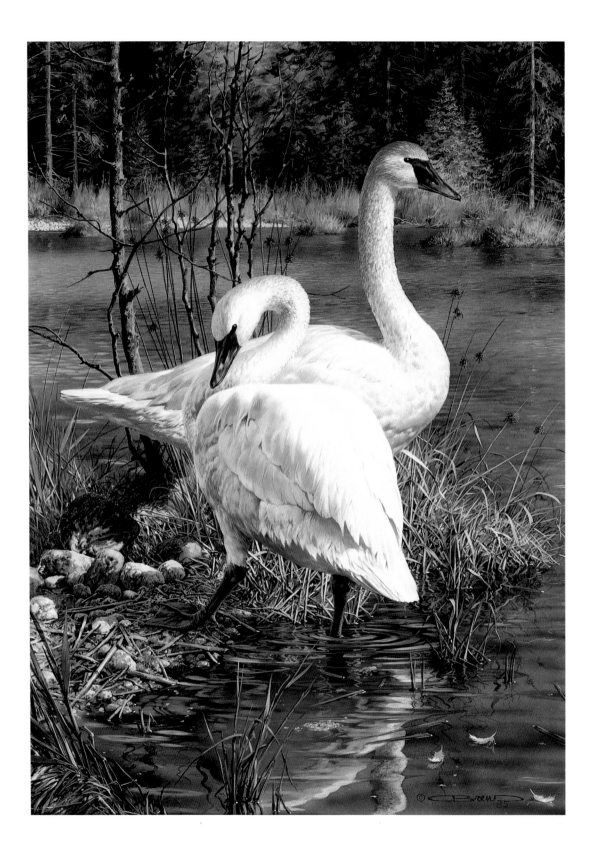

White Elegance—Trumpeter Swans
19½ x 14″, mixed media on board, 1985

PAINTING endangered species gives one a very special feeling. Twenty years ago, I read an article in a magazine about a beautiful species of swan that was being reintroduced into the Yellowstone area of Wyoming—the trumpeter swan.

As I was already a conservationist in those days, I was very impressed by the article and by the beautiful photographs that accompanied it. It made me dream about the large natural world of the United States; I could not then imagine that any American species could be endangered.

Fortunately, the trumpeter swan made a successful return to Yellowstone, and it seems to do well there now. Every time I have gone to the area for fieldwork, I have seen many of them—mostly in the remote wetlands, but sometimes close to the main road. The best sightings were while hiking—coming upon an isolated pond in a forest where a few resting swans were cleaning their feathers. One such moment is captured in this painting.

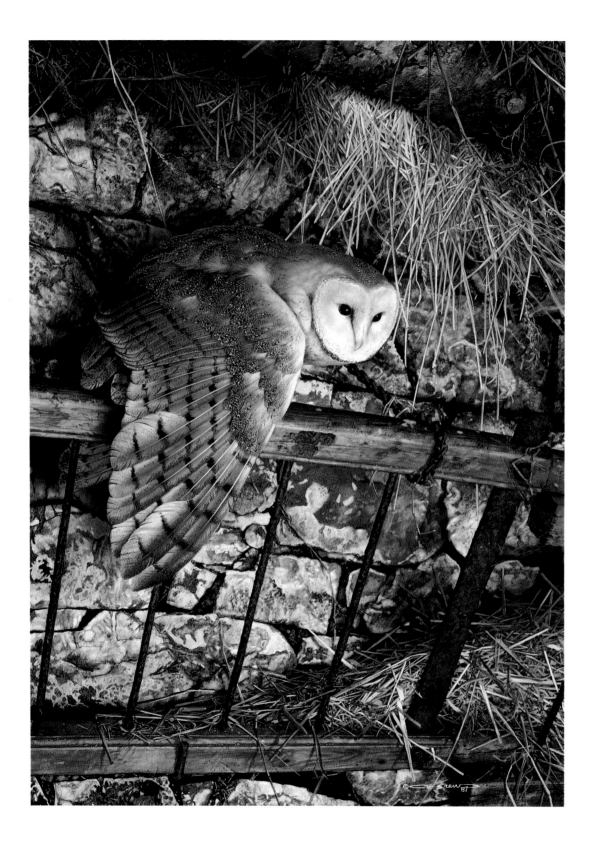

Mysterious Visitor—Barn Owl

33½ x 23½″, gouache on board, 1987

I WILL never get tired of painting owls. In fact, I would like to make a series of owl paintings that shows all the species common to North America. The barn owl is familiar in both the New and the Old Worlds, but it is declining at an alarming rate in Europe.

In Europe, the barn owl is called the "church owl" because it mostly nests in the towers of tall buildings such as churches and castles. Since owls do not worry too much about keeping their nesting places clean, the caretakers of these buildings began to close off the owls' access to them. In addition, the abundant use of insecticides and pesticides has caused a steep decline in the numbers of European barn owls.

I feel very fortunate to be able to travel widely and do fieldwork so that I am able to see a bird that is becoming very rare in my own country.

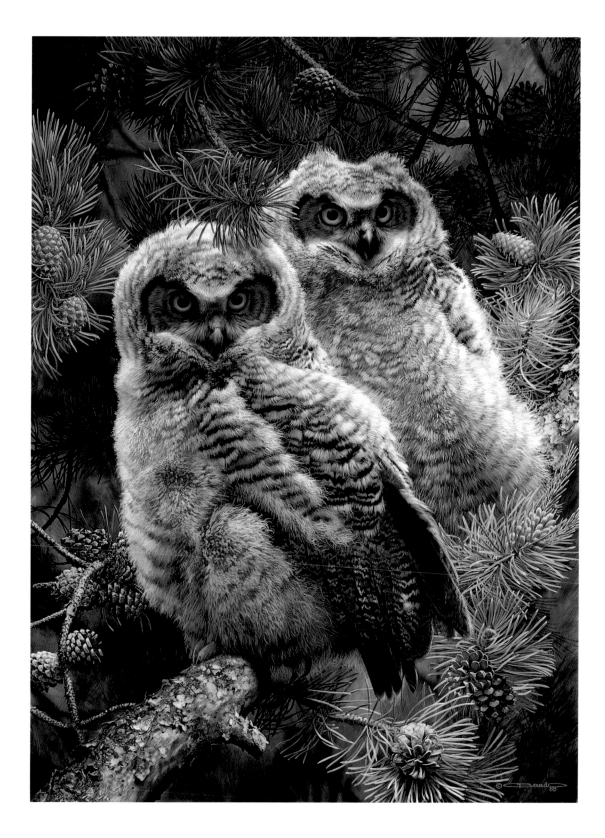

Hidden in the Pines—Immature Great Horned Owls

32½ x 23½", mixed media on board, 1988

THERE is no other subject that suits me as well as wild animals. Portraits or still lifes might be nice to do, but the textures of the fur and plumage of mammals and birds are much more attractive to me. The large variety of forms in the natural world, combined with the many different habitats in which animals live, always inspires new ideas for my paintings.

How can a painter resist these funny-looking youngsters of the great horned owl? Owlets stay near the nest through the spring and summer, still being fed by their parents, developing their powerful talons, silent flying skills, keen vision, and sensitive hearing. Although they still have everything to learn about hunting, they are already real characters. These two just made their maiden flight. Next autumn, they will become the terror of rabbits, squirrels, and mice.

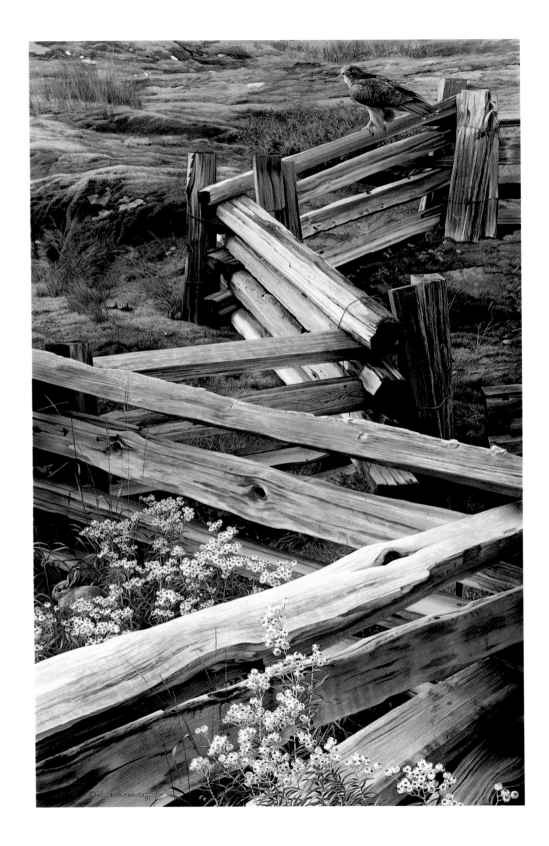

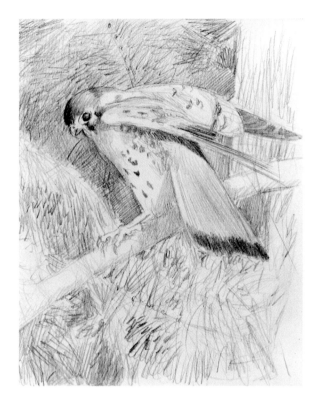

The Balance of Nature
36 x 23″, mixed media on board, 1991

I HAVE a weakness for things made of natural materials such as wood, stone, or clay, especially when they are worked by time and acquire a patina. Traveling throughout North America, I get very excited about the old wooden fences one finds in rural areas; they are excellent for creating a strong composition in a painting. Raptors often choose the fences as a perch. The hawk in this painting becomes part of the zig-zag made by the fence and heightens the feeling of depth.

Red-tailed hawks are very similar to European hawks, but they have considerably more strength in their talons. They are also much more attractive because of their red tails. Their behavior, however, is exactly the same. They prey mostly on small rodents, lizards, and snakes and sometimes even take a rabbit, helping to keep everything in balance. Smart and healthy animals usually escape the attempts of the red-tailed hawk; the rabbit in the painting could be one of them.

The Monarch Is Alive

27⅛ x 37″, mixed media on board, 1990

THE bald eagle, without any doubt one of the most beautiful birds of prey, is a favorite subject of many wildlife artists. In Europe, we have a similar species that lives on the shores of Scotland and Scandinavia, but it lacks the beautiful white head. The thrill I got in seeing a bald eagle in the wild for the first time is difficult to describe. There is no other bird that fits so well with the colors and the light of the wild landscapes in North America.

In my painting, I wanted to capture a scene different from that usually shown by wildlife artists—flying majestically or nobly sitting. I wanted to show the great hunter in action. Here, the bird comes flying out of the right-hand corner, trying to catch its prey sitting on the rocks. Missing its target, it looks for a fraction of a second to see if it can make a second try. A raptor's meal doesn't always come easily.

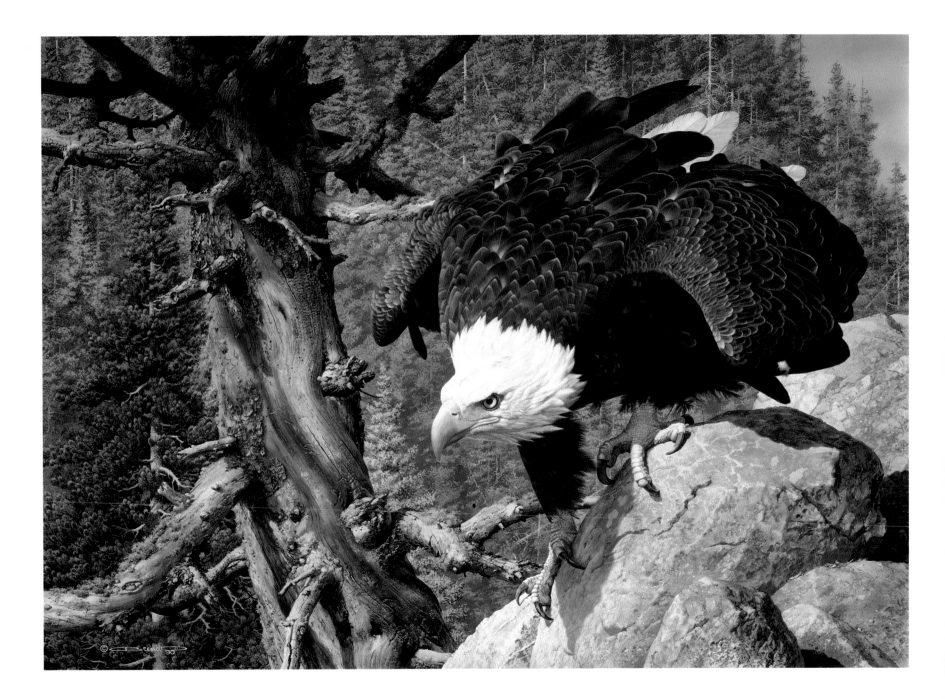

Merlins at the Nest
19¾ x 23⅝″, mixed media on paper, 1984

FALCONS are among my favorite subjects, particularly the two smallest species, the kestrel and the merlin. I enjoy their acrobatic flight and the elegant form of their pointed wings. On the whole, falcons are good parents, and I've tried to capture this in my painting, where I have shown a male merlin caring for his chicks.

Also known as pigeon hawks, merlins are talented hunters, flying low over the ground with steady wing beats, catching birds of their own size such as pigeons and small ducks, as well as insects. It is a delight to watch them snatch large flying insects in mid-air. They also hunt rodents and small mammals on the ground.

Merlins nest in most of the Northwest and from the northern parts of Minnesota and Maine up to the Maritime Provinces of Canada. To give the scene an intercontinental character, I chose to depict this nest in Scotch pine, which is found throughout large areas of the United States and Canada.

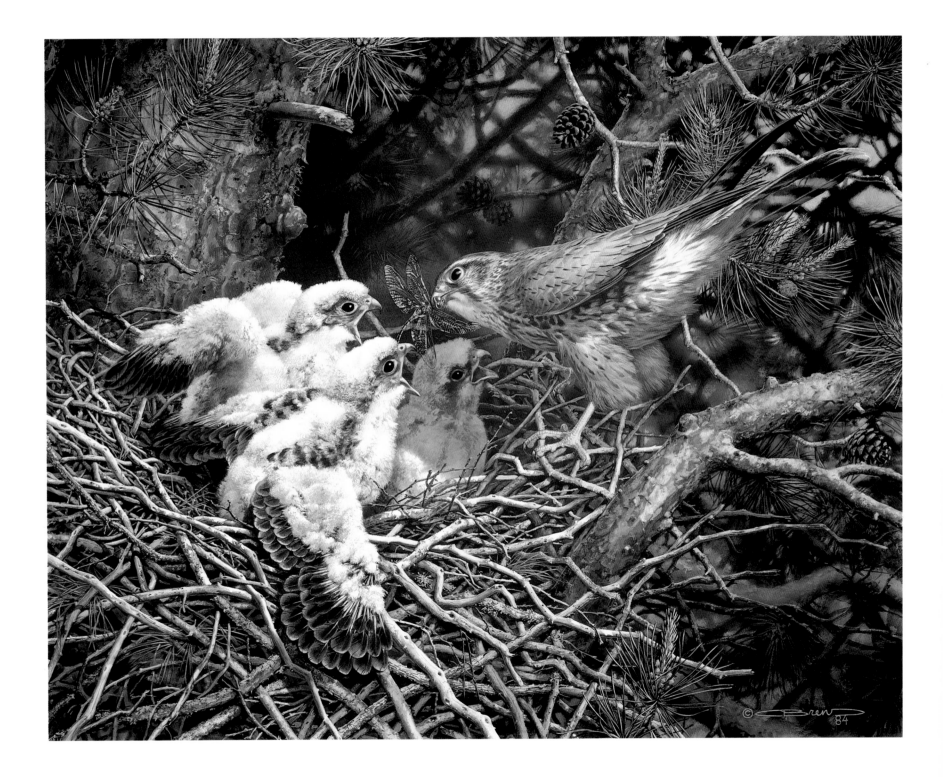

A Threatened Symbol
9 x 12″, mixed media on board, 1987

LOOKING back over man's history, it is clear that animals have always been used as symbols—in religion, heraldry, and many other areas of public life. In Egyptian temples, falcons, cats, and scarab beetles were used as decorative, political, and religious symbols. In the Middle Ages, lions and eagles were used as national symbols in most European countries. The older generation will remember the golden eagle used by the Germans in both world wars. The United States adopted the beautiful, native bald eagle as its national symbol—a wonderful choice, in my opinion.

We are all aware of the fast evolution of technology and our dangerous attitude toward what has always seemed a never-ending supply of natural resources. The bald eagle, the living symbol of the threats posed by this big, new, fast-developing world, is already endangered: without our attention, it could be only a dream to future generations.

For me, wildlife art is the best way to alert the public to what is happening to our own species, mankind. If the eagle leaves us, mankind will follow.

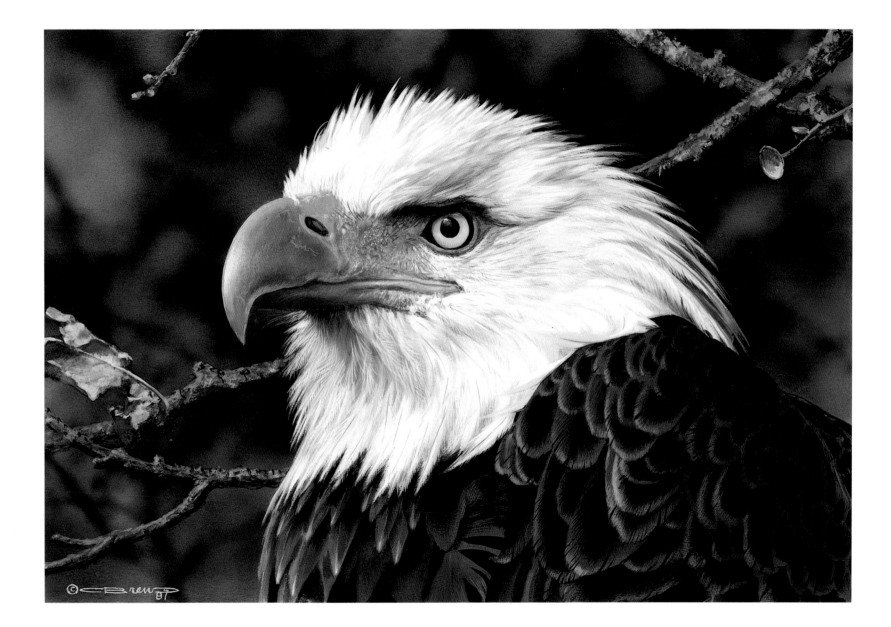

A BRIEF BIOGRAPHY OF THE ARTIST

by Dana Cooper

CARL BRENDERS is irrepressible. The fires of his passions—and he has many—burn too hot to be harnessed by anything other than his own discipline. The controlled perfection of his meticulously rendered wildlife artwork belies the intensity of his nature.

Brenders is a tight, wiry bundle of energy. With his head surrounded by a wild cloud of white hair, he looks the part of an artist. He exudes a contagious enthusiasm. Sometimes irreverent, Brenders is very serious about his artwork and about protecting wildlife and the world's wilderness—he is an outspoken defender of them. Brenders is not a passive person; he has strong beliefs that he is not reluctant to relate; an honest man, he does not sidestep controversy. He is curious, kindhearted, and well loved.

Brenders was born near Antwerp, Belgium, in 1937, the only son in a family of six children raised in strict Roman Catholic fashion. He was an altar boy. Now in his late fifties, Brenders still has something of the look of a mischievous angel. He is a modern, romantic man with a bohemian bent.

Brenders remembers always drawing when he was a boy. He saw proportion and perspective accurately and easily, skills that surprised professional artists at the time. "I think I have a gift—I see very well. I don't mean to be pretentious, I'm just happy to have it." At first, he drew trains, for which he has had a lifetime love; he still collects scale models. It is the elemental power—made from fire and water—rather than the mechanics of steam engines that still thrills him: "They have the aesthetic of

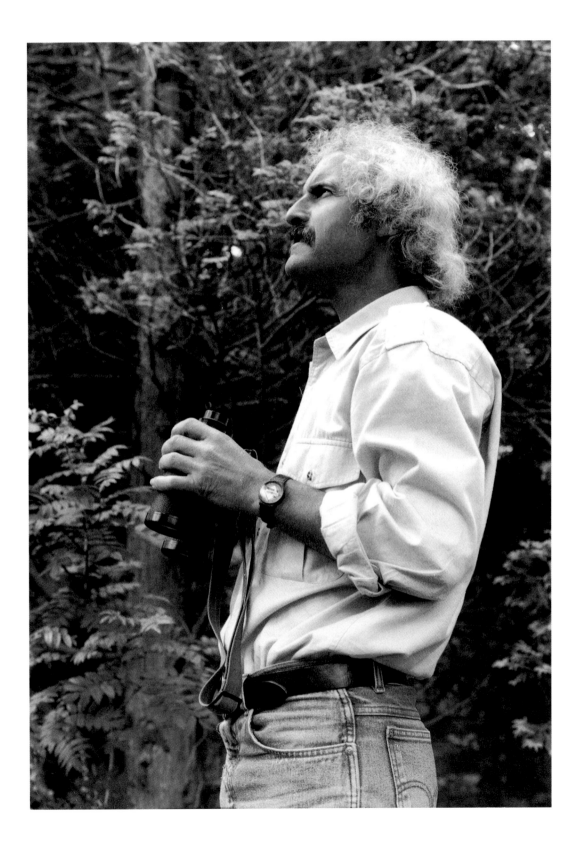

a big animal," he says, "they live and breathe like a dragon." He also drew airplanes, streetcars, ships in the port of Antwerp, Donald Duck, and the uniformed German soldiers who occupied Belgium in his childhood.

As a child, Brenders lived in a farming community on the outskirts of Antwerp. He spent much of his boyhood in the countryside and on the farms of his mother's family. This rural farmland of Brenders' childhood has now been mostly lost to land development due to the small country's rapid population growth. "The country was still beautiful in those days," says Brenders. "I remember the bees and the daisies, the smells of the grasses and the horses and cows on the farms. That was a great time."

Brenders attributes his love of nature to his father, a banker and an amateur photographer. "I always remember my father with a camera. He also could have been an artist." On nature hikes guided by his father, Brenders broadened his love of nature and learned an easy familiarity with photography.

After his son completed the European equivalent of high school, Brenders' father hoped that he would follow his own footsteps into banking. But the boy's mathematical abilities were, he says, "a big catastrophe." It was then decided that art school was his only hope. He first began his studies at a school of decorative arts and went on to study at the Fine Arts Academy in Antwerp.

Brenders' studies in art school were traditional—perspective, figure drawing, human anatomy—much like the Flemish and Dutch masters who trained centuries before him. Brenders was influenced by those masters of his heritage, the realism and attention to detail of sixteenth-century still life painters, and by the Pre-Raphaelites of England.

Brenders' experience of art school was not an uncommon one for realistic painters coming of age in the 1950s. At the time, the art vogue was nonrepresentational. Brenders believes that art is a product of its time, and that movements in art in the middle of this century were heavily influenced by politics, philosophy, literature, and intellectualism. He says that modern artists "live with body and soul in the chaos of our modern life, with all its wars, religions, competition, and lack of love. The fear of apocalypse hangs in the air." But, he asks, "who wants to hang the misery of the world on his wall?"

Brenders has always admired the work of modern abstract, expressionist, and surrealist painters. Most of the paintings in his home are, in fact, the work of artists

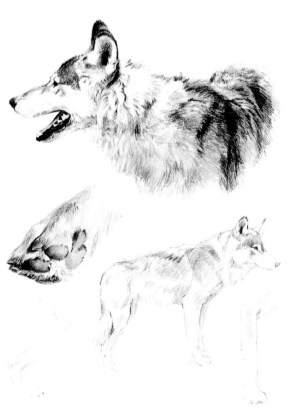

who paint in a loose style very different from his own. In art school, however, he struggled with confusion about the value of painting realistically, of painting wildlife and nature. He experimented with abstract and surrealistic art, but he felt he had no message to express in this style of painting, and he finally realized that his heart was not in it, that his heart was where it always was, in nature. Among his contemporary wildlife artists, he very much admires the work of Raymond Harris-Ching.

Following art school, and like most of his fellow students, Brenders entered the world of commercial art, working in printing, publishing, and advertising as an illustrator. Brenders began his commercial art career in advertising, and in the early 1960s began working as an illustrator for a publishing house in Antwerp. He spent twelve years there, eight of them directing a studio of eight artists. Brenders worked on a variety of illustration jobs, including mail order catalogs that sold everything, including fur coats. He would distribute the catalog assignments among his staff artists, but, he says, "I always took the furs; I enjoyed those textures—fox, rabbit, mink—I guess I still do."

In 1970, he began to work as a freelance illustrator for publishers in Belgium, Switzerland, and Paris. Much of his commercial work at this time was nature illustration for book publishers. He worked on a series of educational books on endangered species as well as birds and butterflies. One of his major assignments was participating in a series of books entitled *The Secret Life of Animals*. As the interest in wildlife art grew and as wildlife art galleries began opening across Europe, Brenders, already with a considerable body of original work from his nature illustration, began to exhibit his original wildlife paintings in Belgium, France, Holland, and Spain. His paintings began to sell.

Brenders' early work was collected by European aristocrats with hunting traditions. Exposed in these circles, Brenders' art was fortuitously noticed by an agent, Christiane Thorn Katcham, at an exhibit in Brussels. A fellow Belgian with family hunting traditions of her own, Katcham not only believed in Brenders' wildlife art, but also had a vision of what it could become with more extensive fieldwork and greater exposure. She became his agent. In the early 1980s, Katcham brought Brenders to the United States, where the collection of original wildlife art was much broader than in Europe. It was on this visit that Brenders fell in love with North American wilderness areas. For Brenders, coming to America this first time and seeing Yellowstone National Park was like the stories of Jack London come alive.

In 1983, Katcham introduced Brenders' work to the American wildlife art scene in an exhibition at Trailside Americana, a major wildlife art gallery in Jackson Hole, Wyoming. It was there that Brenders' work was seen by Laurie Lewin Simms of the publishing house Mill Pond Press. A contract was signed the next day, and Mill Pond Press soon thereafter began to publish limited-edition reproductions of Brenders' original artwork.

Since 1985, Brenders' original paintings have been included regularly in the prestigious Leigh Yawkey Woodson Art Museum's Birds in Art and Wildlife in Art exhibits. He annually shows with the Society of Animal Artists, where he has also received honors and awards from the public and from his fellow wildlife artists. Brenders was also the 1993 Artist of the Year at the Pacific Rim Wildlife Art Show in Tacoma, Washington. His artwork has received widespread critical acclaim and has become immensely popular; more than seventy editions of Brenders' limited-edition wildlife art prints have now been collected worldwide.

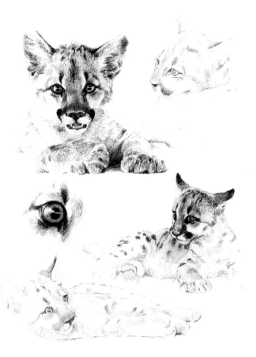

Brenders' many years as an illustrator gave him valuable experience. As a commercial artist, he explored techniques and tools and laid the groundwork for what would ultimately evolve into his present technique, which he calls his "cuisine." He learned his painting technique on his own, developing and refining it over thirty years. "If you really want to achieve a particular effect," Brenders says, "you will find it. I didn't learn it in art school."

Brenders can work on one painting for months. His technique is a painstaking process, preceded by research and fieldwork, which are critical to the accuracy of his art. He can spend hours photographing paws, tails, or talons. Once, after shooting a dozen rolls of reference film for a painting of otters, there was not one frame he liked. Even after spending weeks of research and photography in the field, the artist devotes more time to develop the concept and composition of the painting. With this planned, he first makes a complete pencil drawing of the entire subject, including the background.

Over his pencil work he then paints with sepia watercolor, much like pen-and-ink drawing. On top of the sepia he airbrushes areas in watercolor and then paints over all this with gouache. He finds the combination of gouache and watercolor perfectly suited to his detailed work; it achieves an effect he finds impossible with acrylic or oil paint. Only the Flemish masters, says Brenders, could achieve such detail in oils.

Working for hours with infinite patience and perceptible delight, sometimes covering an area only inches across, Brenders caresses his brushes with beautifully tapered, elegant fingers, making nearly imperceptible brushstrokes. He says he happily works "like a monk," listening to music or to the BBC on the radio. Not fond of rising early, Brenders usually works late into the night without food or coffee; sometimes he does not stop until dawn.

Brenders says that wildlife art is not only the result of experiences in the field, but that imagination forms the basis for many beautiful wildlife paintings. Often, the only way for the artist to get close to animals in a natural setting is in his imagination: "It's often frustrating to see animals in nature, because they almost always run away; one rarely sees them up close. I bring the animals close to the viewer—what I paint is nearly impossible to see in the wild. In my scenes of nature, I like to share the experience of being within the intimate world of the animals—a little moment in paradise together with them." Brenders feels very fortunate to be able to express his imagination: "I think that this is a big advantage that artists have; we can imagine a scene with such reality that the impossible becomes possible."

In addition to imagination, inspiration is a key to Brenders' work. His inspirations are driven by the harmonies of color and texture in nature and, he says, by "the thrill of encounters with wild creatures." Brenders can be inspired by the elegant, elongated line of a cougar's hind leg or by the bright yellow plumage of a meadowlark. He says, "Inspiration is a strange thing and can come to you in very unexpected ways—sometimes in the field, sometimes in a bookshop. It can happen any moment of the day."

Keen of eye and perception, there is little in this world that escapes Brenders' attention. In his detailed paintings (which are often mistaken for photographs), in his observations of nature and of the behavior of wildlife or humans, Brenders doesn't miss a trick. To him, omitting a detail would be disrespectful to nature: "If there is a God," he says, "He is in nature." Everything is worthy for inclusion in Brenders' paintings—tiny pebbles, dried grasses, broken twigs. What might be considered irrelevant to another artist is honored by Brenders and rendered to perfection. "My disease is perfectionism," he says. Brenders paints every rock because, he says, "I feel what's underneath." If he could, he would also put the smell of the mosses and the leaves into his paintings.

"Art is an explosion of impressions, and I have to make my impressions visi-

ble," says Brenders. He tells of ancient Japanese artists who would stand in front of their canvases or silk panels until they felt a kind of tension. They could stand there a long time before it came upon them, but when it happened they would work quickly to capture their art. "I have that tension, too," says Brenders, "but I have a big conflict because I'm devoted to details. My impressions are too complicated. One thousand details make it impossible to make the explosion happen."

Modest about his talent, Brenders claims: "I am not an artist; I am a painter. I don't sell art, I sell my work. I leave it to the public to decide if it's art or not. I am not a philosopher, I just paint animals. I only worry about beauty. I want to create something that has not been done before, and I think I do. If details can make my work more beautiful, then I will try to make my work more detailed than it already is, even if it drives me crazy. With all the ugliness in the world, I am thirsty for beauty. And, I remember very well what my father said before he died: 'Boy, all beauty is in nature.'"

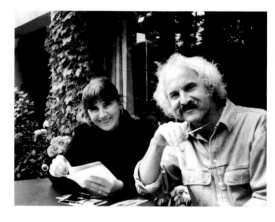

Only when he is in nature—out-of-doors, hiking, photographing, or researching—is Brenders completely happy. He finds his balance in the forests and other wilds. "I want to be able to live under the big sky, in the rhythm of nature." His American publisher, calling him to ask after the progress of a painting, often discovers that he is not in his studio, but is outside working in his garden, perfecting his personal wilderness.

Brenders still lives outside Antwerp, amid the diminishing Belgian farmlands, with his wife, Paula. Their home is filled with collections of pottery, glass, paintings and sculpture, many of which are simple objects of the earth made by hand—art forms of simplicity and utility. Brenders appreciates those things that withstand and improve with time.

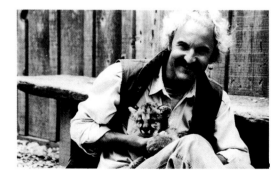

Brenders still fidgets under the altar boy's robes. He is often ready to escape the responsibilities of his talent—the deadlines, the schedules, the itineraries. He cannot be shut in a room for very long if the weather is nice. First, he will start looking longingly out the window, and shortly after that he will lay plans to make his escape. Brenders is an unabashed lover of life who is able to harmonize his passions and his discipline. He may enjoy an occasional irreverence, but Carl Brenders reveres above all else the wild beauty of nature.